O'Keeffe

Wright

Frank Lloyd

Georgia

O'Keeffe

Wright

Frank Lloyd

Georgia

HDi

HARPER
DESIGN
international

An Imprint of HarperCollins*Publishers*

Publisher: **Paco Asensio**

Editorial Coordination and text: **Llorenç Bonet & Sol Kliczkowski (pages 10-36)**

Translation: **Wendy Grieswold**

Art Director: **Mireia Casanovas Soley**

Graphic Design & Layout: **Emma Termes Parera**

Artworks of Georgia O'Keffee: © **Georgia O'Keeffe Foundation. VEGAP Barcelona, 2003**

Photograph of Georgia O'Keeffe: **Malcolm Varon**

Drawings and photograph of Frank Lloyd Wright: © **Frank Lloyd Wright Foundation. VEGAP Barcelona, 2003**

Photographs of Wright's buildings: **Scot Zimmerman, Paul Rocheleau (pages 13, 24 , 25, 26, 27, 40),
Pep Escoda (pages 34, 35, 39, 50, 53)**

First published in 2003 by:
Harper Design International,
an imprint of HarperCollins*Publishers*
10 East 53rd Street
New York, NY 10022

Distributed throughout the world by:
HarperCollins International
10 East 53rd Street
New York, NY 10022
Tel: (212) 207-7000
Fax: (212) 207-7654

HarperCollins books may be purchased for educational, business, or sales promotional use. For information, please write:
Special Markets Department HarperCollins Publishers Inc. 10 East 53rd Street New York, NY 10022

Library of Congress Control Number: 2003109564

ISBN: 0-06-056420-2
DL: B-33.587-03

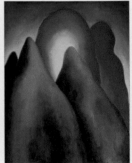

Editorial project

LOFT Publications
Via Laietana, 32 4º Of. 92
08003 Barcelona. España
Tel.: +34 932 688 088
Fax: +34 932 687 073
e-mail: loft@loftpublications.com
www.loftpublications.com

Printed by:
Anman Gràfiques del Vallès, Spain

October 2003

Contents

FRANK LLOYD WRIGHT-GEORGIA O'KEEFFE

Georgia O'Keeffe and Frank Lloyd Wright are two pioneers of American art and culture. Both were recognized during their lifetimes as geniuses, trendsetters, and enduring inspiration for future generations. Despite being part of the continuum of Western culture, they were both aware that their work was also a departure from European tradition and the consolidation of an American art closely related to its territory and settings. Both were fascinated by the Eastern cultures and never wanted to be part of an avant-garde trend or movement that entailed abandoning their individuality – an ever-present trait of US culture.

Despite their age difference, both made a pivotal journey from north to south and from east to west in their own country, a journey that is an intrinsic part of modern American mythology. Film, the great artistic medium of the twentieth century, has described this voyage ad nauseam, from westerns to road movies, and it is through this medium that the conquest of the West has become part of contemporary mythology, recognizable in every corner of the planet. This movement westward represented, to the two artists, a crucial decision in their lives, which would change their lifestyles and their relationships with the environment. The climate of Frank Lloyd Wright's native Wisconsin began to be too hard for his fragile health, and so, in the mid-1930s, he moved to Taliesin West, his final residence. Also in the same desert but in a different state, in the mid-1930s, O'Keeffe would be spending more and

more time in New Mexico. It was to this same desert that she would relocate permanently in 1946. This pivotal journey from both artists' native Wisconsin to the desert of New Mexico and Arizona is peppered with countless travels, especially within the United States.

Throughout the twentieth century, the United States had become a dominant military power in the political and economic evolution of the entire planet and an extremely rich cultural wellspring. Frank Lloyd Wright and Georgia O'Keeffe are two pioneers of US art, the first to create an American language increasingly personal and independent of other countries. While American literature was firmly established in its own right by the mid-nineteenth century, painting and architecture were still dependent on Europe. Wright and O'Keeffe are among the firsts artists who did not have to depend on Europe to create and embark on independent careers, following their personal interests and motivations, not needing to copy or wanting to join the avant-garde movements that were dominant in Europe. Neither O'Keeffe nor Wright went to Europe as students to complete their training. While Wright's mentor, Louis Henry Sullivan (1856-1924), one of the most innovative and individualistic architects of his day, considered studying in Europe a necessity for his career, Wright refused the offer of an opportunity to complete his training in Paris and Italy, feeling his time would be better spent remaining at Sullivan's side.

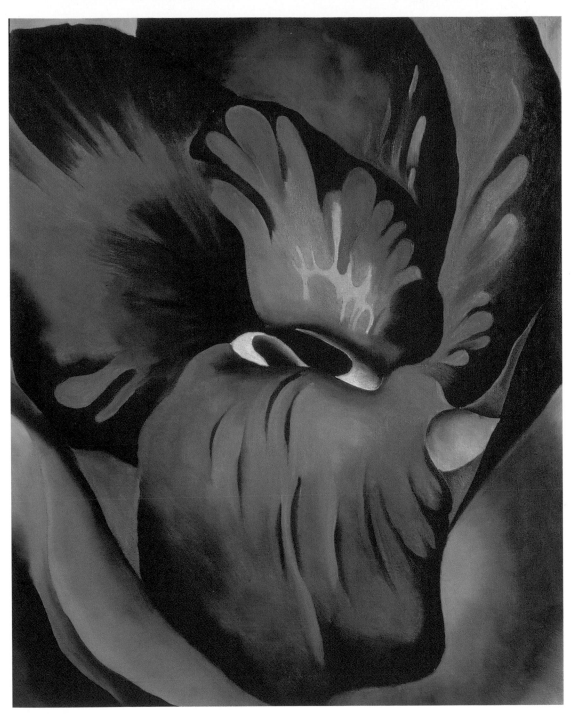

Canna, Red and Orange
1926. Oil on canvas (16 x 20 inches)

FRANK LLOYD WRIGHT

FRANK LLOYD WRIGHT 1867-1959

Due to the creative and innovative nature of his work, architect Frank Lloyd Wright is considered one of the precursors of contemporary architecture. Wright's prolific oeuvre (more than one thousand buildings) is proof of a diverse inheritance from various avant-garde movements such as Cubism, Expressionism, Arts and Crafts, Art Nouveau, Rationalism and Minimalism. Wright's work stands out for the way in which it unites new materials and grants functionality to different spaces.

Wright's private life was marked by unfortunate scandals such as the fire that consumed his house, Taliesin East, and caused the death of seven people, among them Mamah Borthwick Cheney, the woman for whom the architect had abandoned his family a few years earlier. Among the succession of women that accompanied Wright throughout his life there was Miriam Noel, whose mental instability resulted in her incarceration. Despite a turbulent private life, Wright was a tenacious worker, and his career progressed unyieldingly, enriched by experimentation with innovative techniques.

Wright's inclination for architecture began to take shape in early childhood. His primary boyhood pastime was Froebel blocks, invented by the kindergarten pioneer and consisting of a series of spheres, blocks, pyramids and paper strips. They permitted the young Wright to experiment with multiple combinations, which proved decisive in his spatial and analytical training. A parallel can be drawn from these geometric games and conjugation of elements to the formal character Wright's design style would later take. Another influence in Wright's development was Unitarianism, a religion that encourages the individual to seek God in the world. This creed, which had an influence on the entire Wright clan, was the nucleus of the architect's personal exploration, a spiritual journey that looked to science and art as the vehicles by which one could come to know God.

Wright's architectural language is noteworthy for the use of geometric elements and horizontal and vertical lines in walls. As a result walls are independent from the interior structure, such as in the Johnson Building (Wisconsin). The resulting breakdown of elements allows the qualities of each element to stand out. Furthermore, the work of the celebrated architect also reflects a Japanese influence.

Within the catalogue of Wright's work there are two kinds of homes, both of his own invention: Prairie houses (1904-1909) and Usonian houses (1939-1940). Wright conceived the first with certain common characteristics in mind: horizontality; roofs that go beyond the limit established by low walls and longitudinal windows; an elevated groundfloor; an important relation with nature and landscape; and an open layout. Usonian houses, on the other hand, represent a more modern and pragmatic form of expression. Instead of being large spaces to accommodate guests, Usonian homes are smaller and more intimate,

Hanna Residence, 1936

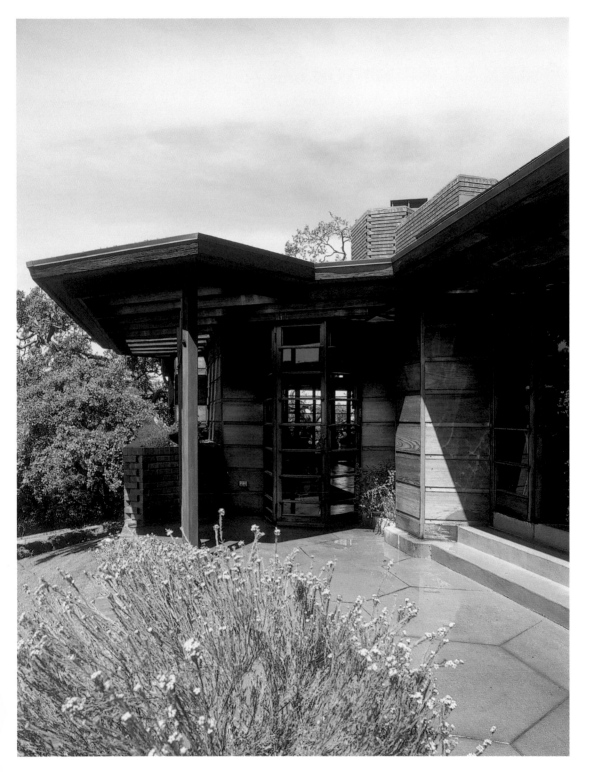

designed to meet individual necessity. Wright understood "uso-nia" as an expression of the ideal life in the United States, and with this notion in mind he conceived the Usonian model. A Usonian home often has L-shaped floors. It maintains the open-layout character of the Prairie house while doing away with its more formal aspects. In the Usonian model is also found the uti-lization of natural materials and ornaments.

The experimentation with different forms inspired Wright to design an integrated furniture ensemble as well as independent pieces, given his belief that "distinct" spaces require "distinct" forms. Color, light and shadow characterize Wright's buildings. With these resources he was able to create intimate, luminous spaces, in addition to the well-known stained-glass windows that give rise to environments of peculiar character.

There is an ongoing playful dialogue with scale in Wright's work. This is true of the Unity Church and the residences, both of which communicate a dramatic sense of spaciousness, as well as the Morris Store. Spatial conception is one of Wright's main concerns, and different environments are articulated with few separations occurring between them. The ceiling is the ele-ment that joins the spaces while always maintaining its own identity, thereby disassociating itself from the whole.

The integration of nature is evident in the use of materials that combine air, water, land and fire. As can been seen in the Fallingwater House, the Storer House or the H. C. Price House, the architecture coalesces in the stone, water, and vegetation. In all of these constructions Wright demonstrates complete aware-ness of spatial determination.

Fallingwater House, 1935-1939

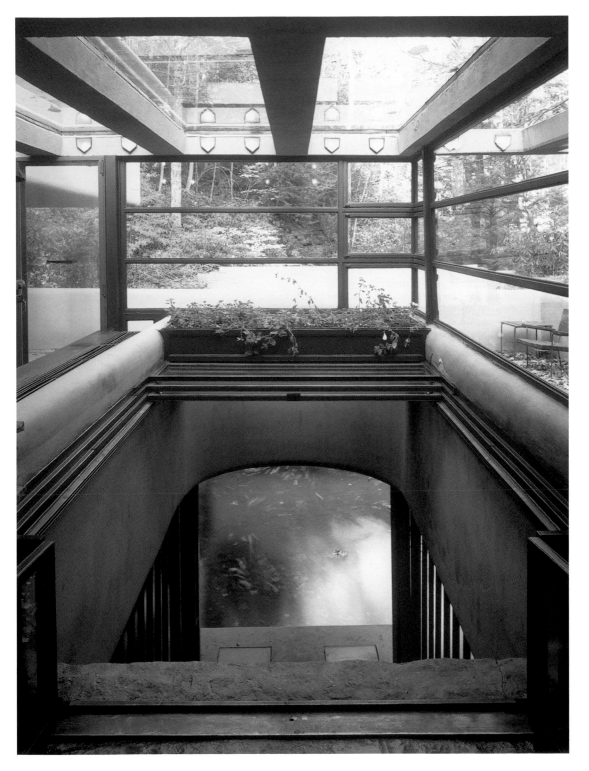

TALIESIN EAST

1911-1959

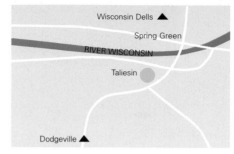

Spring Green, Wisconsin, US

In Gaelic, the language of Wright's ancestors, "taliesin" means "bright peak," so Wright took this word from Gaelic mythology for the weekend house that he built in 1911. Taliesin would undergo multiple additions, renovations, and reconstructions throughout the years, becoming the lengthiest project of the architect's life.

The work was born of Wright's need to escape the bustle of Chicago and return to his birthplace in Wisconsin. His mother's family, the Wright Joneses, had settled there around 1865. Over time the family prospered, accumulating a dozen farms scattered across the region. Wright designed a bucolic refuge on one of these plots which he later transformed into a residence, studio, and workshop. The structure was enhanced by the restoration of nearby edifices such as a windmill, an old school, and a small restaurant.

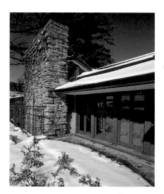

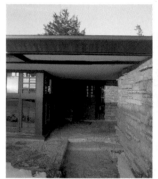

Tragic fires in 1914 and 1925 required that Taliesin be almost completely rebuilt. The resulting buildings were christened Taliesin II (1914-1925) and Taliesin III (1925-1959). The one-story stone and wood structure is strategically placed at the top of a hill with a magnificent view. The exquisite design and meticulous craftsmanship resulted in a richness that included a great of variety of finishes and imaginative solutions. This precision is evident in the varied size and shape of the stones used to create the textured walls. The wood partitions that separate the different rooms feature strips going in different directions, perforated with small openings that grant the environments a dynamic quality. As in nearly all of Wright's works, the furniture was designed specifically to satisfy the functional as well as aesthetic needs of the project.

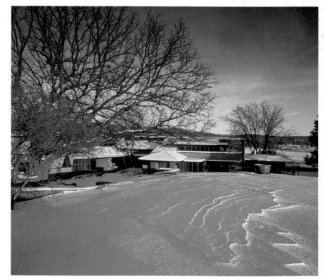

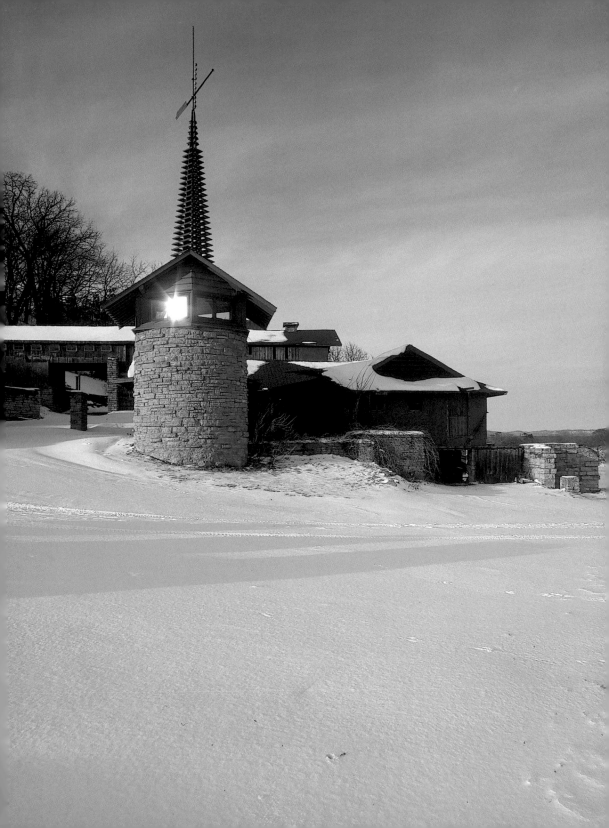

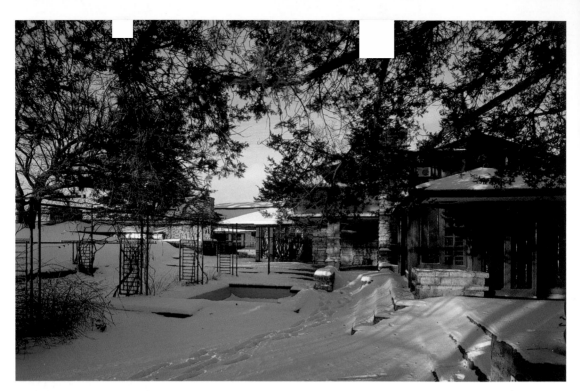

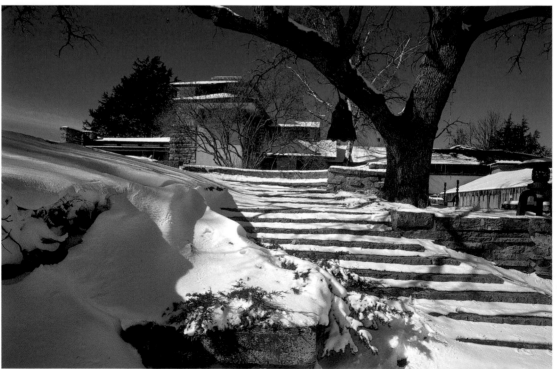

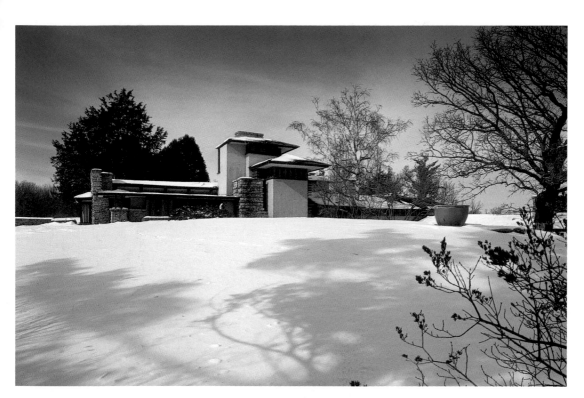

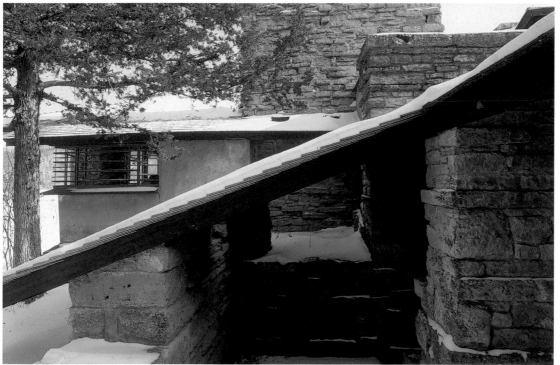

HOLLYHOCK HOUSE

1917-1920

Los Ángeles, California, US

Originally intended as a full theater complex, this project was carried out under the auspices of Aline Barnsdall, heiress to the Barnsdall Oil Company. Barnsdall's passion for the theater resulted in the purchase of a vast property in the center of Los Angeles, Olive Hill, at the foot of which a large theater, a cinema, housing for actors and actresses, and several stores and businesses were to be built. At the summit would be Barnsdall's house, Hollyhock. While plans for the theater did not materialize, Barnsdall's house and two others were built.

When construction began in 1917, Los Angeles was still a desert. It was therefore necessary to irrigate and landscape the lot to achieve the desired lush landscape. Given the intensity of the sun in the region, Wright conceived of a main house with an introspective character. To this end, Wright created a tree-covered interior patio to provide shade. He also designed smaller windows than those of his Prairie homes. Sliding glass doors blur the limits between interiors and exterior.

In the midst of the once arid desert, water is granted a prominent role. Wright created a brook that circulates from a fountain to a large pond on the patio, continuing into the interior of the house in front of the fireplace and into a square swimming pool before the living room windows.

In this work, which Wright himself qualified as "California romance design," the relationship with nature, harmoniously achieved through large sculpture-like volumes, also appears in the decorative motif of the hollyhock—Barnsdall's favorite flower. The flower was used to ornament the windowsills, colonnades, and concrete gardens, as well as the house's custom-designed chair backs. While this project proved to be the most difficult of Wright's residential commissions, due as much to the perfectionism of the client as that of the architect himself, he would remember the period fondly.

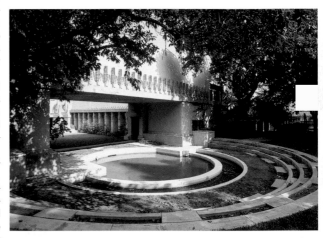

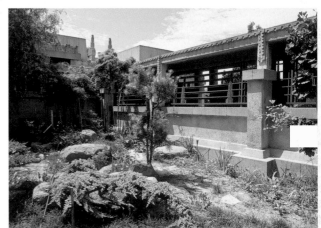

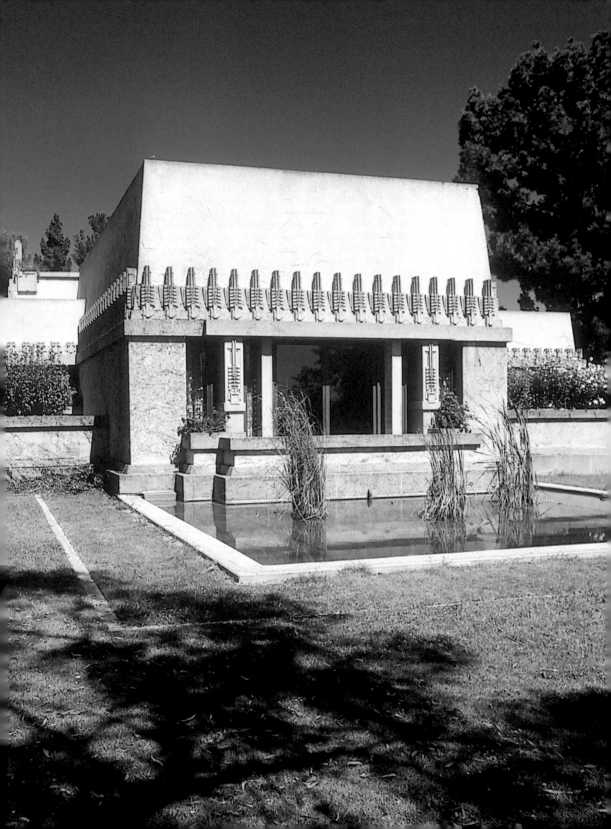

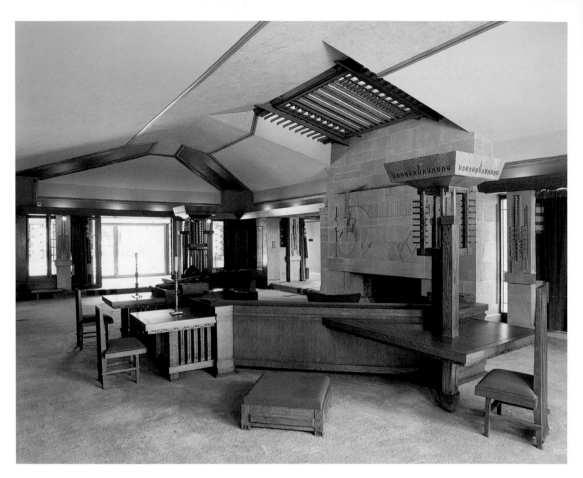

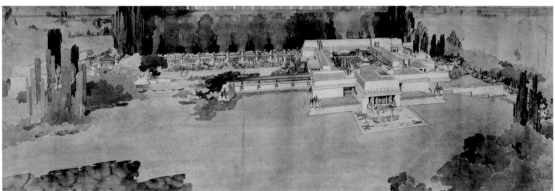

Perspective

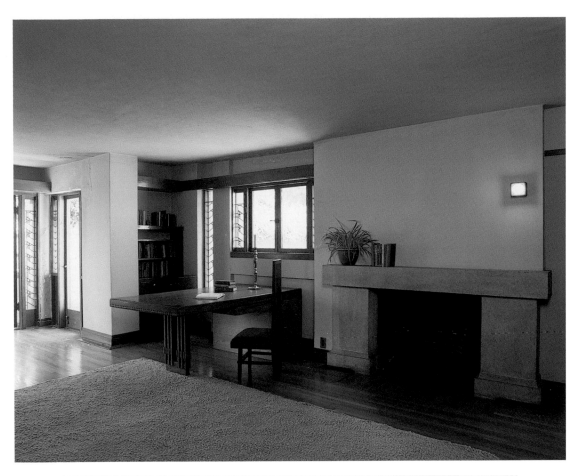

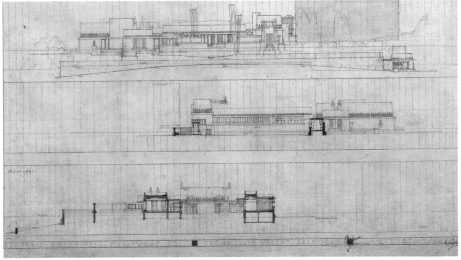

Section and elevation

0 4 8

STORER RESIDENCE

1923

This home is one of Frank Lloyd Wright's prefabricated buildings using indigenous granite. In contrast to other designs, here the subtle transition between interior and exterior is less apparent. The home is situated above street level. Ascending two sections of stairs, one reaches the main patio and a fountain that terminates in a small swimming pool. On the first façade level, five glass doors alternate with stone-block columns decorated in geometric motifs.

These doors provide direct access to the dining room, which along with the second-floor living room make up the nucleus of the house. The result is a large luminous space in which the walls indicate the geometric configuration of the stone blocks. The home benefits from a north-south orientation. Light enters through windows and glass doors that alleviate the solidity of the stone. The layout of the home gives the spaces considerable mobility and invites fluid circulation between the different levels.

Despite the exterior appearance, the house is arranged in four levels with their own environment and space. The four identical bedrooms are located on the level between the living room and dining room. The dining room and kitchen occupy the first floor, along with awing dedicated to service rooms and a small room that surrounds the chimney. The living room extends across the entire level, with terraces that open onto the garden.

With changes in ownership the home underwent a series of remodeling attempts. Finally, in 1970 at the request of the new owner, Eric Lloyd Wright, son of the renowned architect and himself a collaborator on the original design, restored the home and installed electric heat and a new swimming pool. Wright's original intention, however, was preserved in the balance between the transparency of the glass and the solidity of the stone, and the dramatic opening of the home to the exterior.

Hollywood, California, US

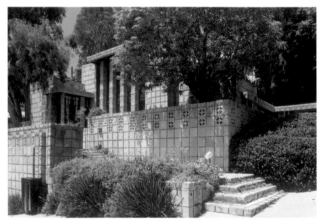

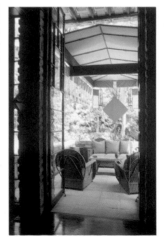

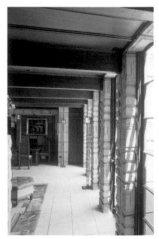

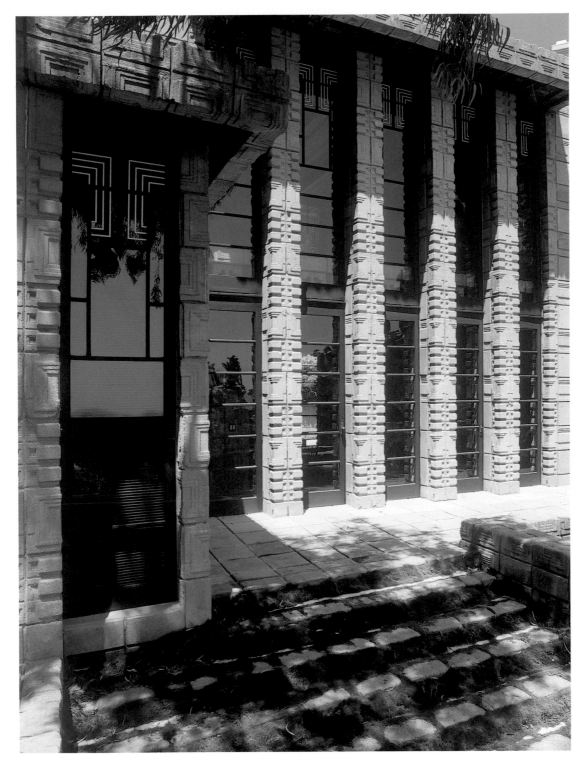

FALLINGWATER HOUSE

1935-1939

Bear Run, Pennsylvania, US

Of all Wright's constructions, Fallingwater House is perhaps the most famous. An elevated building situated on a waterfall, the home sits between the Pennsylvania hills and is adapted perfectly to the form of the rocks.

With this house, Wright sought to join the elements of nature—forest, river, and rock—with the construction materials. The goal was to create a building for rest and relaxation in harmony with the setting. The relationship with nature is characteristic of Wright's work, yet in this design the architect accentuates the intimacy the occupants share with the vegetation and exterior landscape.

The architect celebrates horizontality by calling attention to the projection of the living room and that of the upper terraces. The main home consists of three stories. The main floor, with two terraces, offers a view in three directions. On the upper floor each of the bedrooms has its own terrace, as do the third-floor study and balcony. A semicircular walk goes from the main house to the guesthouse, situated slightly further up on the hill.

The home is accessed by crossing a small bridge and following a narrow passageway in back of the house. The entrance is small so as to call attention to the ample, luminous living room space to which it gives way. Structure plays a major role here, evidenced by the suspended stairs that lead down to the water level.

The vertical elements of the house are of local stone, and together with relief work gives the house a sculpture-like quality. The horizontal elements are made of reinforced concrete. The floors and walls are stone-covered, with fine-grained walnut woodwork.

With this project, Wright felt free to break with architectural convention, and gave his fertile imagination free reign, unlimited by symmetry, walls, geometric schemes, or privileged points of view. Research into structures to maintain the house atop the waterfall advanced slowly and structural problems—partially resolved—have troubled the home for some years.

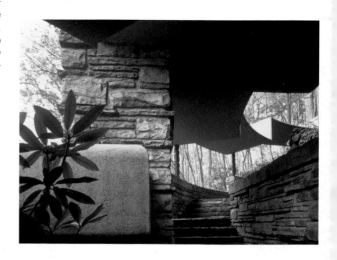

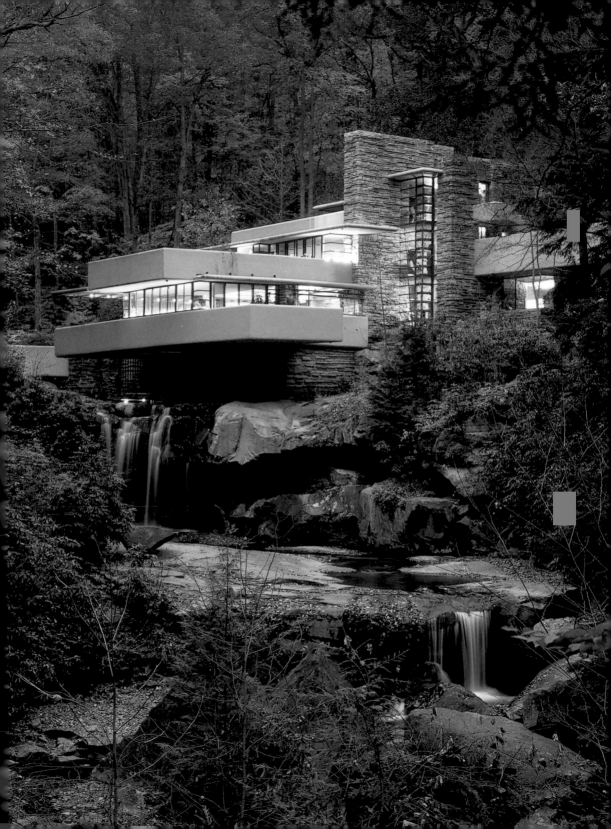

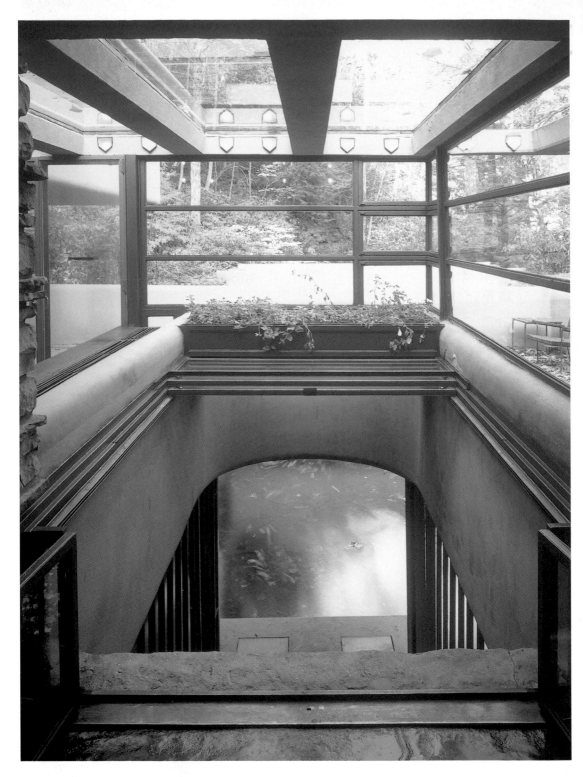

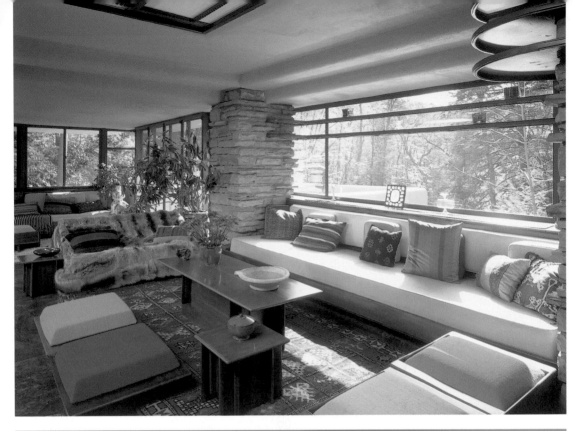
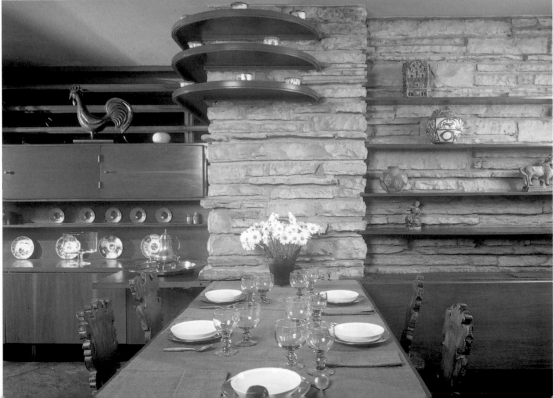

TALIESIN WEST

1938-1959

Scottsdale, Arizona, US

Following his first trip to Arizona in 1927, Wright reiterated, on several occasions, his intention to return and to build a refuge from the harsh winters of his Wisconsin home in the desert region of Sonara.

In 1937, Wright decided to buy a lot northeast of the town of Scottsdale at the foot of the McDowell mountain range. It was here, atop a summit, where Wright and his young disciples designed and built the winter home and studio that would be dubbed Taliesin West. The complex includes residences, drafting rooms, a workshop, a store, and two theaters surrounded by various gardens and terraces. It served as the home and workplace for the architect, his family, and the apprentices who made up the Taliesin Fellowship, a course for architectural students created by Wright and his third wife Olgivanna, in 1932.

The project was literally born of the desert. The students collaborated in the collection of local rocks and sand, the primary materials in the construction. The skillful use of indigenous materials results in a perfect integration of the structure with the surrounding landscape. Even the selection of color emphasizes the relation between the complex and the desert surrounding it.

Taliesin West unfolds along an axis that joins the access area and the leisure area. A triangular space halfway between these two points contains the workshops, the dining room, and lavatories. All of the rooms open to landscaped terraces with views of the plateau. The homes, almost all of which were student design experiments, are scattered across the grounds.

The structural system of the complex consists of wide-stone walls and a roof system in the form of a sequoia-beam framework. White-cloth remnants between the secondary beams provide the camp-like atmosphere that Wright sought and glass panels were installed to reinforce the roofs.

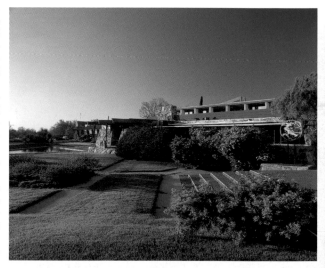

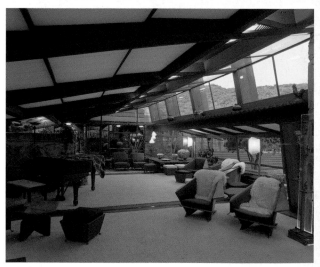

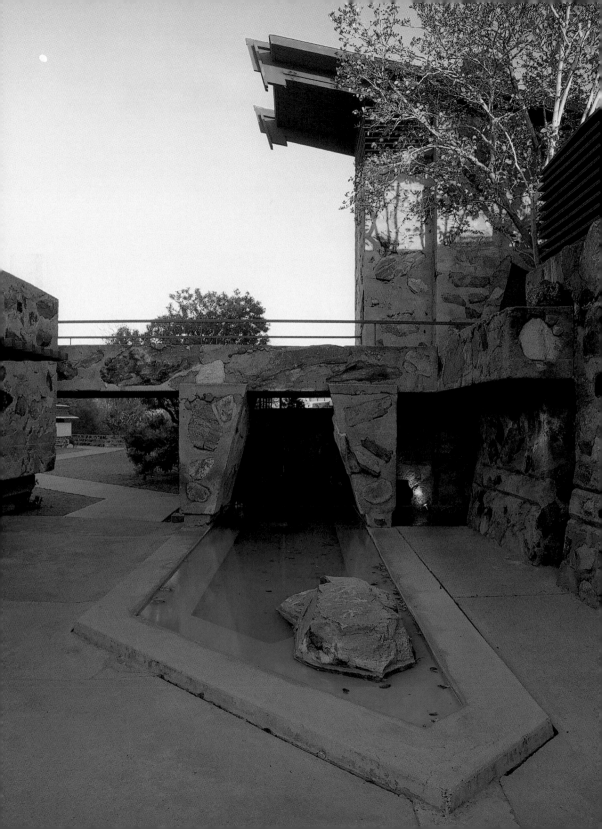

FLORIDA SOUTHERN COLLEGE

1938-1959

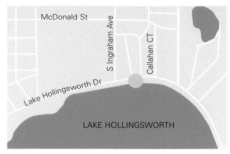

Lakeland, Florida, US

This construction consists of different buildings arranged asymmetrically in an ordered fashion. Here the architect returns to themes of earlier years, revealing a special fondness for sixty and thirty degree angles used structurally and ornamentally.

Pfeiffer Chapel is entered through the shadow of a concrete structure that plays with the juxtaposition of forms. Pfeiffer Chapel consists of a double triangle in the form of a glass-and-concrete diamond. The Roux Library complements the chapel, and its design plays with a diamond motif. The administrative building consists of a double structure united by an intermediary patio. A large grassy green was designed for the enjoyment and relaxation of the students, and unifies the complex.

Complications with the plans postponed construction of the university complex for many years. The result was scattered but harmonious, yet Wright's signature lines and materials are evident throughout the buildings. The solidity of the concrete is softened by metal and glass, geometric openings, and latticework that permits the passage of light. The drawings and designs on the walls and columns create a kinetic effect unusual in such solid constructions. The grayish colors are also balanced by the use of red and vivid colors in the garden.

The Florida Southern College complex allowed the architect to focus his creative energies into an urban landscape spread across spacious grounds. The architect knew how to take advantage of this opportunity, and conceived of an entire alternative city.

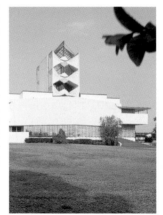

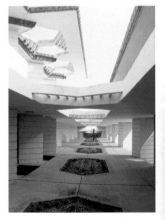

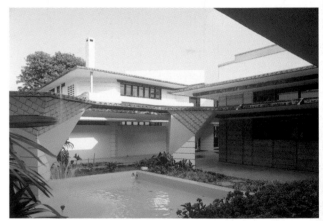

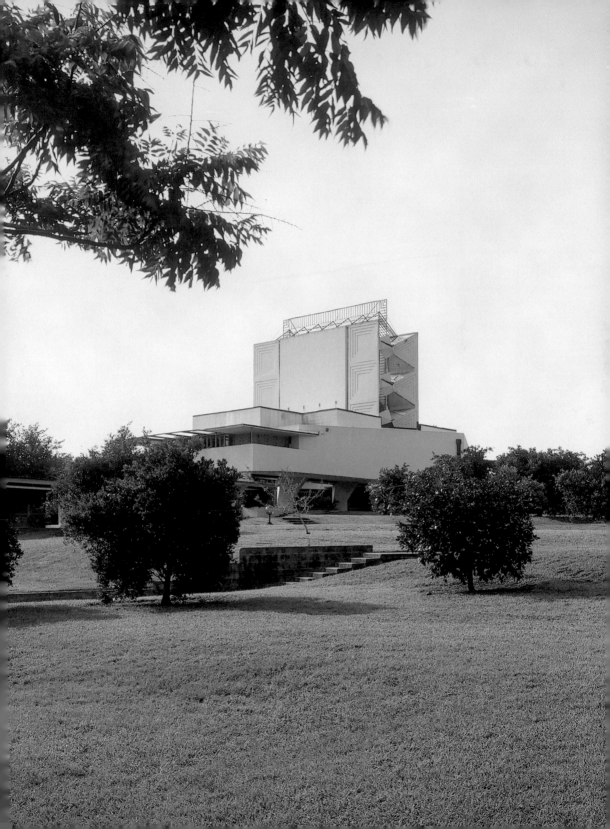

V.C. MORRIS GIFT SHOP

1948-1950

San Francisco, California, US

With this building, Wright proves that a store can grab attention without an elaborate showcase. The project involved remodeling an existing warehouse on a narrow San Francisco street, rather than construction from scratch.

The building facade stands out among the neighboring edifices as a result of the horizontal use of the bricks, a more striking effect than glass. An asymmetric arch affords a complete view of the interior and welcomes the visitor. The juxtaposition of glass and crystal gives rise to play between notions of solidity and transparency. The visitor is greeted by a path of lights that run along the wall and beneath the arch, trailing off into the interior.

From the discreet but still monumental facade, access is gained to the large interior space. The interior breaks with the stolid exterior thanks to a dramatic interplay of forms. A spiral ramp joins the ground floor with the upper level and opens up the space with a line of movement that follows the theme of circles, arches, and curves. This design is heir to the Guggenheim Museum (whose plans date from 1943 though not built until later), where Wright first used the interior ramp as a central design element. The ceiling is covered with a framework of plastic concave and convex lamps and the curved walls are decorated with openings and circular ox eyes. A concrete flowerpot continues the convex form of the ceiling and is visible from both levels of the store.

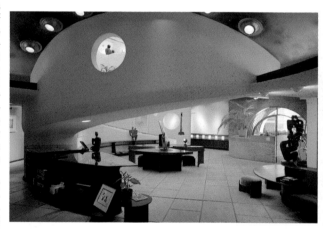

At the client's request, Wright designed independent furniture, made by Manuel Sandoval, elegantly displayed for sale in the store. Round armchairs with cushions and semicircular tables facilitate the selection of items and guarantee the shoppers' comfort.

After this project the Morris's commissioned Wright to design three homes that were never built. Today, the store houses an art gallery, allowing the public to appreciate an important part of the architect's legacy.

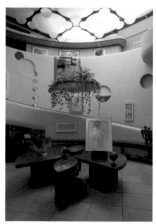

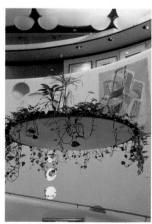

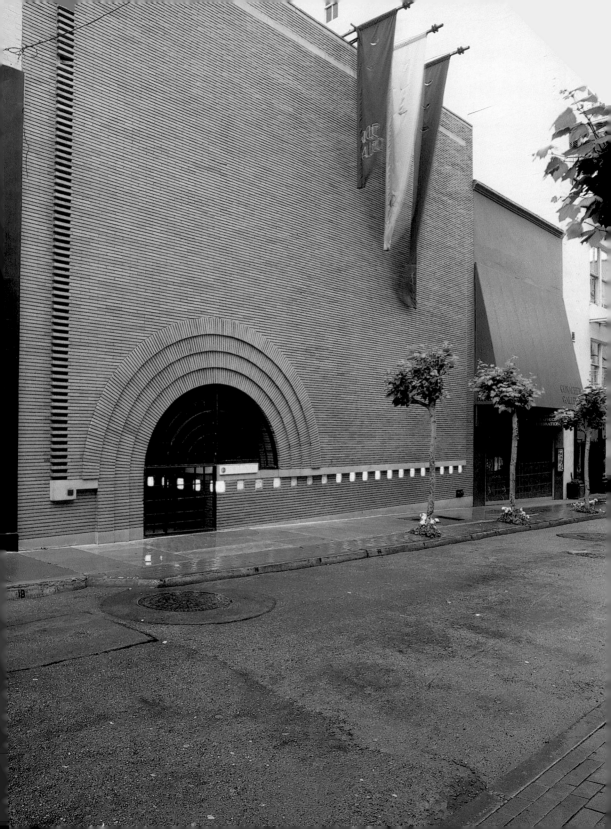

Solomon R. Guggenheim Museum

New York, New York, US

1955-1959

With this work, Wright reached the pinnacle of his career, and gained the respect of a city traditionally suspicious of western based innovations like those of the Chicago School. The Guggenheim audaciously breaks with conventional, linear box-room museum design with a continuous, ramped spiral trajectory. Controversy also surrounded the relation the building would have to the city. Wright proposed a spiral, open to the urban space and presenting the structural interior with clarity. Wright's concept was that the visitor to the museum would ascend by elevator to the upper level and gradually descend via the ramp which overlooks an open patio. In this way the visitor could travel via elevator from all levels and arrive at the end of the exhibition on the ground floor, close to the exit. Guggenheim liked the idea and supported it energetically, until his death in 1949. Despite his support, construction was postponed due to changes in site conditions and museum plans, as well as rising material costs. With the exception of a few final details, the museum was completed by the time of Wright's death.

The controversy unleashed by the museum also penetrated artistic circles. Some artists argued that the inclining walls and the ramp were not conducive to the proper display of the paintings. In response, Wright argued that by slightly inclining the walls, the paintings actually benefited from the resulting improvement in perspective and lighting. This powerful work of architecture stands out not only as a home for a diverse range of artistic works, but as a masterpiece itself, establishing a symbolically intriguing dialogue between container and content.

When asked what his most important building was, Wright answered "The next one." From this we may deduce that the Guggenheim Museum, which was his last, was, at least for the architect, his principal achievement.

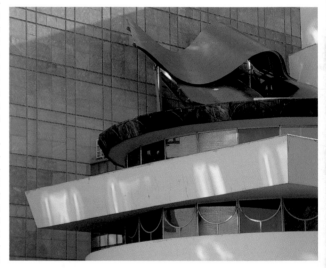

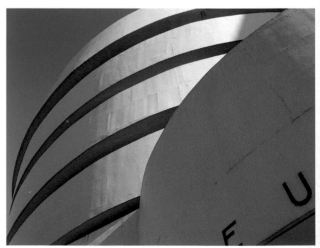

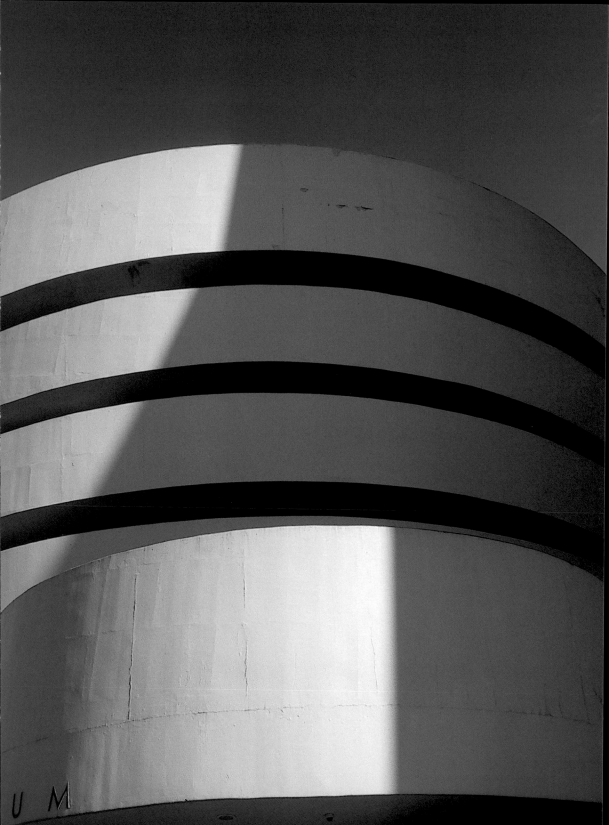

MARIN COUNTY CIVIC CENTER

San Rafael, California, US

1957

Wright was already advanced in years when he took on his first and only governmental commission, a new civic center north of San Francisco, in San Rafael. The architect set the building in a vast park with a lake and small hills, adapting the construction to the imperfections in the terrain.

Rather than be constrained by the landscape, Wright was inspired. As is apparent in the two wings of the building flanked by a pair of hills, Wright incorporated nature into the design. One of these wings contains the administrative department while the other the courthouse. Both feature views of the interior garden and exterior lake.

In contrast with other official buildings, the Marin County Civic Center maintains a human scale, making constant reference to the landscape and surrounding nature. This quality is also characteristic of the interior: between the two main buildings runs a landscaped walk illuminated by glass ceilings.

The whole stands out for its exuberant and playful aspect, qualities not usually found in official government buildings. Wright joins circles, spheres, or semicircles in structural and decorative combinations, highlighting the curved forms that compose the construction. The decoration becomes, as Wright himself stated, an integral part of the building. From the exterior of the building this gives rise to a highly energetic visual rhythm, with changes in the proportion of arches and openings from level to level. A central patio functions as a communicating axis for all the levels and the nucleus around which the various offices extend. The walls and partitions are mobile and can to the spatial of each department. The concrete and steel materials used harmonize with the setting as much by virtue of their color as by their placement.

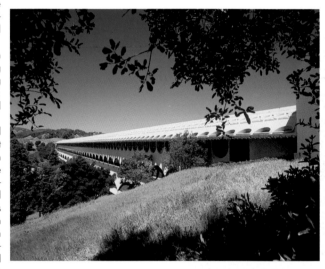

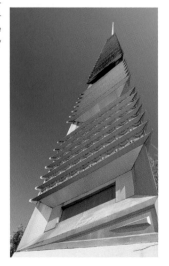

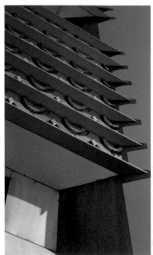

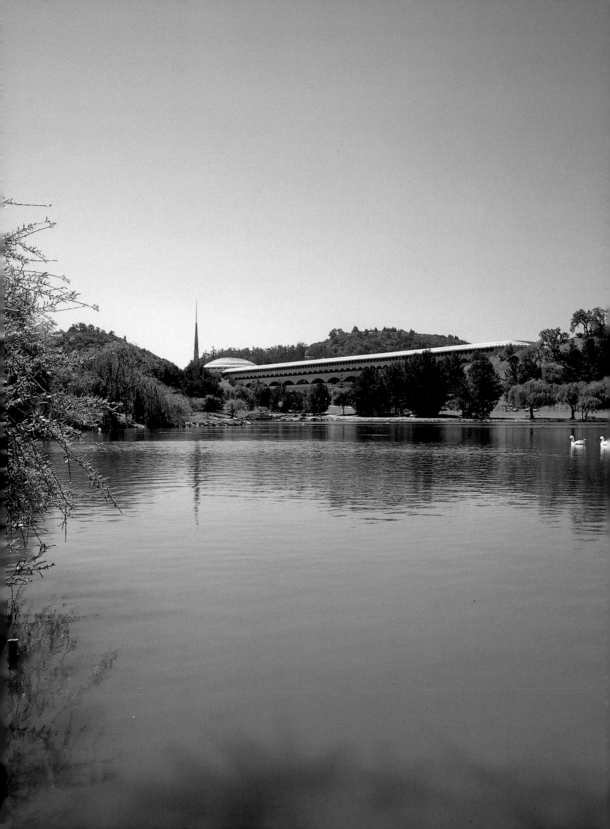

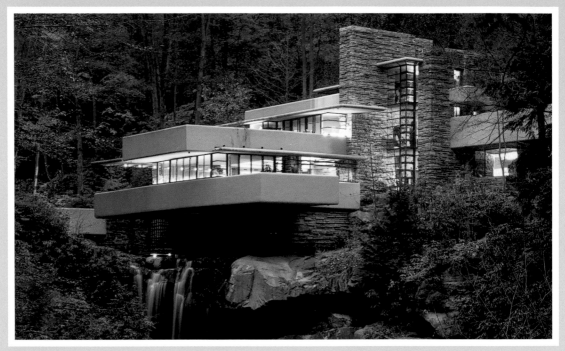

Fallingwater House

LANDSCAPE

Romanticism and picturesque

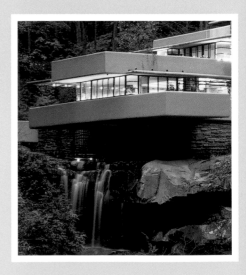

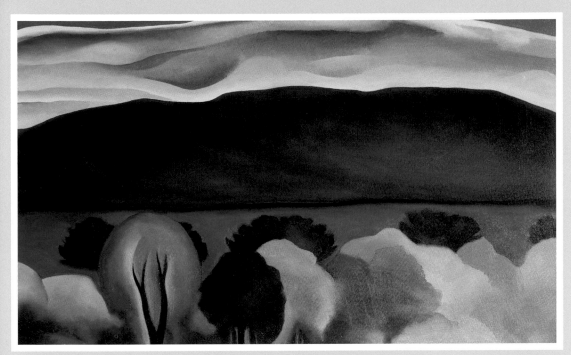

Lake George Blue
1926. Oil on canvas (18 x 30 inches)

The landscapes of Georgia O'Keeffe present a virgin state of nature untouched by man, much like the gardens that surround Wright's houses, which aim to preserve the natural state of the landscape. With his objective to integrate architecture and nature, Wright pursues the traditional picturesque gardens of English romanticism, in the same way O'Keeffe follows the romantic trail of landscape painting, whose most famous painter is Kaspar David Friedrich (1774-1840).

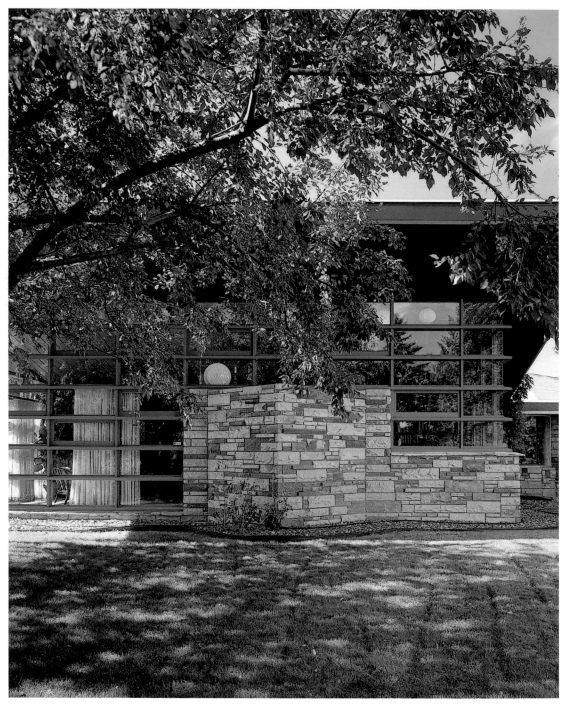

Blair House

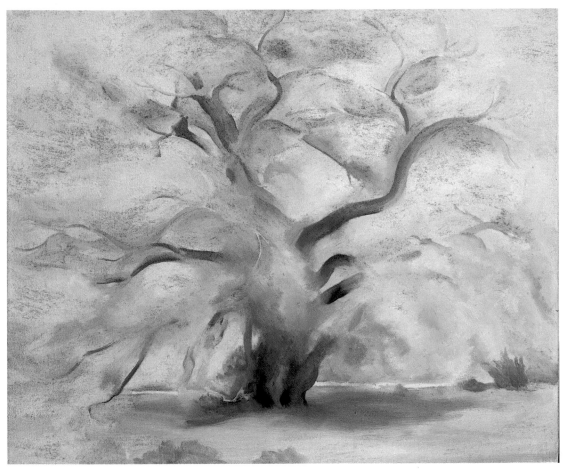

Cottonwoods Near Abiquiu
1954. Oil on canvas (22 x 26 inches)

In Fallingwater, in the Prairie Houses, and even in his urban design projects, Frank Lloyd Wright was always clearly motivated by the desire to mix open spaces, with a profusion of vegetation, and the home's interior spaces, separating the two with windows. In many of his drawings, the importance of the plant world is clear from the large trees and lush gardens that he depicted, planned with as much care and devotion as the structure itself. This respect for nature is doubtless an outgrowth of his love for the dense woods of his native Wisconsin. His respect for the plant world and, especially, for big trees, comes from both this rural upbringing and Japan and Europe, where the great trees are respected. But, while this concept includes respect for the great trees that were already on the property during the various expansions of Taliesin, Wright's choosing to design a house with a large tree, even though there were none on the property, and even though it had to be imported exactly like construction material, is more personal. This implies that nature is part of the architectural project per se, and that a century-old tree can be drawn where one does not exist and can be brought there and, as in the construction of a building, it can be erected where once there was nothing.

This inclusion of nature as part of the architectural design itself (now known as

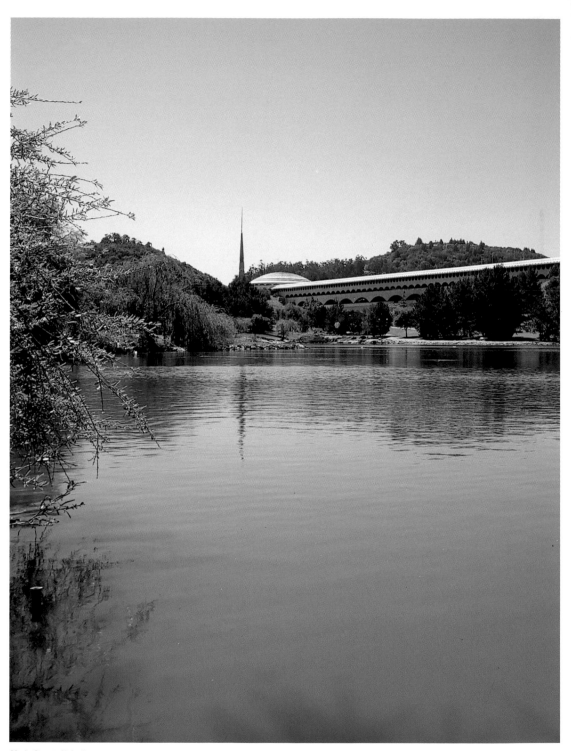

Marin County Civic Center

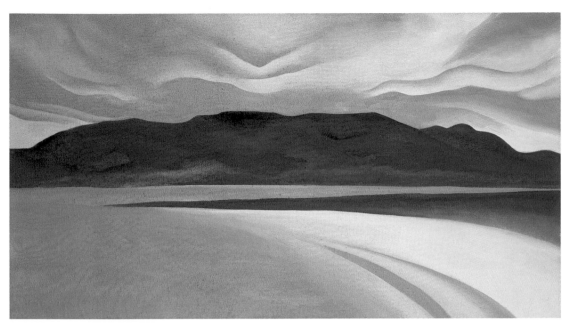

Lake George
1922. Oil on canvas (18 x 32 ¼ inches)

landscaping) was not due exclusively to early conservationist ideas, with which Wright more or less agreed, but was already present in the late eighteenth century and, in some places, much earlier. Picturesque painting, for example, did not involve making direct copies of a landscape, but rather, it was considered more beautiful for the painter to create an ideal landscape, depicting a known setting with large trees or waterfalls where none actually existed. In a short time, this concept made the transition to architecture, and architects began to design gardens to look natural, although everything was as calculated as a painting. One of the best-known exponents is Karl Friedrich Schinkel (1781-1841) who, as architect to the Prussian king and much of the nobility, designed various houses with large gardens in Potsdam, on the outskirts of Berlin. Every square-inch of these garden projects was planned, and trees were planted so that, one day, a large solitary tree would mark the main entrance to the house, or so that another tree would stand in a perfectly straight line between the palace tower and a distant church spire.

In the late nineteenth and early twentieth centuries, when the young Wright was carving out a reputation as an architect, these ideas were somewhat dated, but they were widely known. And Wright's passion for working with natural elements would be more prominent because the European architects of his generation were focusing all their hopes and dreams on the big cities, far from Wright's ideals, in a country with many spaces that were still virtually untouched.

Georgia O'Keeffe's connection with the world of romanticism and her pleasure in working with trees and nature was very different from that of the architect, but it was also born in a country where there were still places untouched by human hands. But, before her interest in vast landscapes, O'Keeffe began her artistic adventure with a fascination for small natural objects, such as a flower, a tree, or a seashell. The artist's communion with nature is one of the foundations of O'Keeffe's work. She wanted to literally merge with her work at the moment of its creation. The theoretical texts of Kandinsky and texts on Eastern aesthetics and art

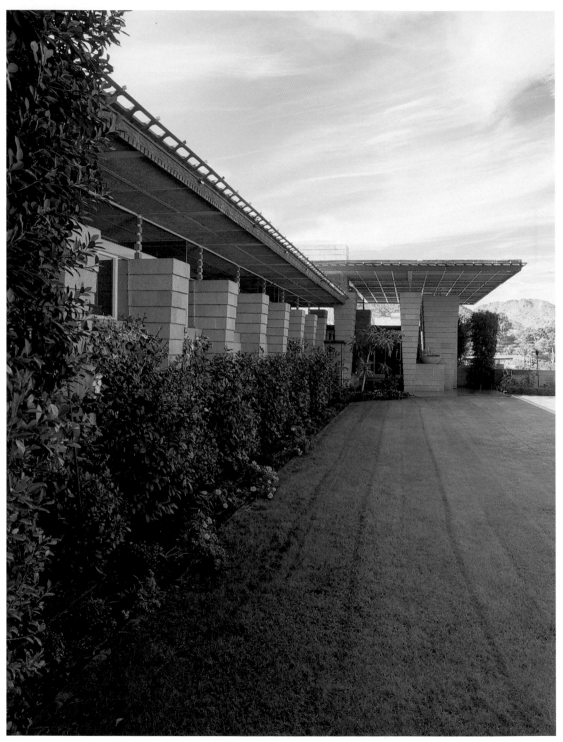

H. C. Price House

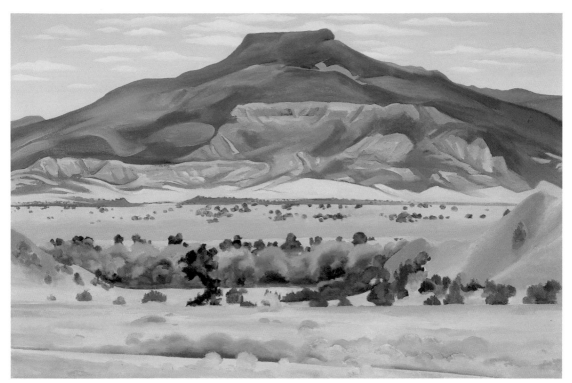

My Front Yard, Summer
1941. Oil on canvas (20 x 30 inches)

were basic to the cultivation of this sensitivity, but the connection with the Western landscape tradition is very evident in her work.

In O'Keeffe's United States, virgin landscapes were a reality. A trip could mean going to an unknown place, or a place known only through a black-and-white photo and a brief encyclopedia article. From this perspective, the possibility of exploring an unknown landscape, as O'Keeffe did with her old Ford in the New Mexico desert, was a real adventure, full of surprise and beauty. The depth of emotion with which she describes her impressions of her first trip south recall once again romanticism, the dominant school of thought of the time, which still survives, in which a storm or a landscape vibrant with the last rays of the sun was considered an example of the sublime.

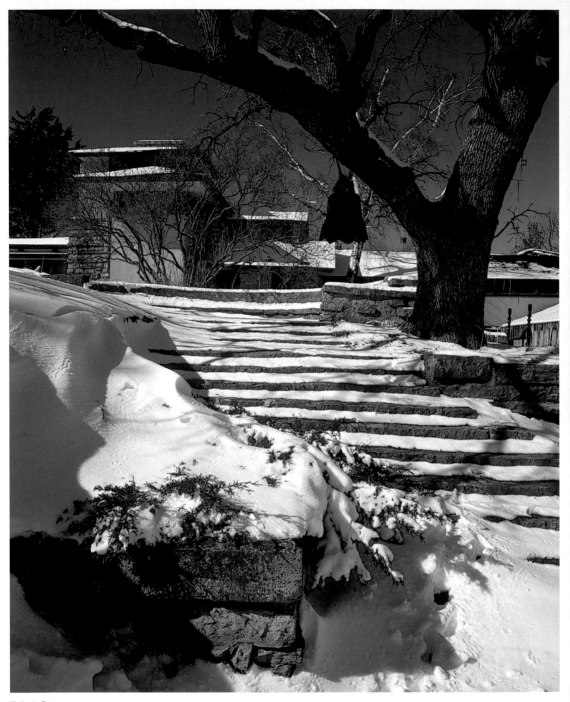

Taliesin East

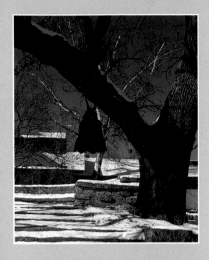

Wright made constant changes to Taliesin, as he did to all his houses, but despite these and the unfortunate accident in which the house burned down, he tried to respect the environment as much as possible. Also, in many cases he integrated existing trees into the house itself. The large tree between two terraces (see photo) marks the approach to the staircase that joins them and the site of a large Japanese bell. The bell was used to call the residents to meals, in keeping with the custom of Wisconsin farmers.

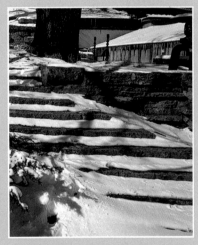

Wright had to build a buttress to support the big tree. The stairs, crossing diagonally from one terrace to the other, are integrated with the building and the setting, allowing oblique perspectives of the two perpendicular wings that surround the two terraces. Wright always took great care with regard to his buildings' relationship with the setting, from the large windows to the gardens they usually survey.

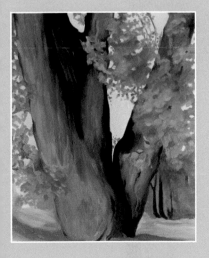

Untitled (Cottonwood Tree), 1945, Oil on board, (24 ¼ x 20 inches). O'Keeffe painted various trees throughout her career, always from different perspectives. Her need to merge with the trees as she depicted them allowed her to detach herself from her surroundings and concentrate only on the features that interested her at the moment. The cropped composition, which rarely includes the entire object, makes for a somewhat abstract vision and obliges the viewer to focus on a specific quality, be it its solidity, the color range, or the texture of its surface.

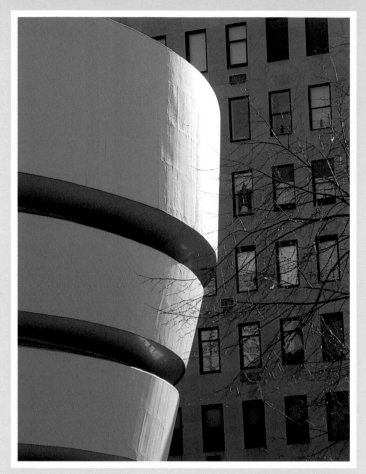

Solomon R. Guggenheim Museum

ORGANIC FORMS

Nature and abstraction

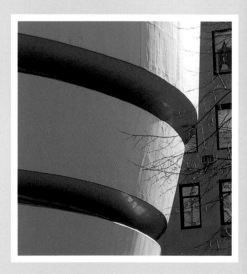

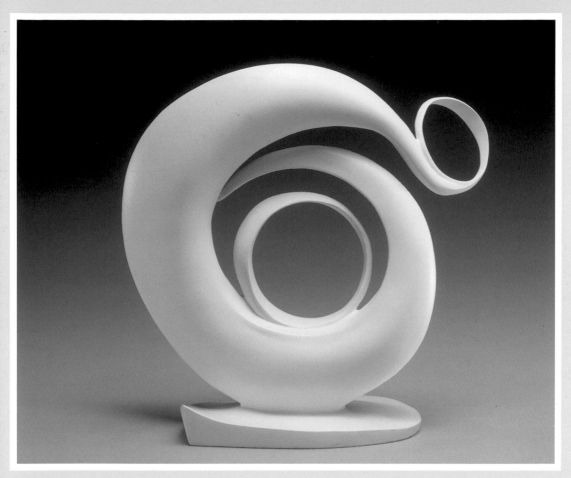

Abstraction
1946. (cast 1979-1980) white-lacquered bronze (10 x 10 x 1$^{1/2}$)

Both Georgia O'Keeffe and Frank Lloyd Wright affirmed, throughout their careers, that one of the best sources of inspiration was the direct observation of nature. However, this approach did not bring them to create a world copied from nature; rather, having internalized the reality, they could create a totally personal world, often tending toward abstract forms.

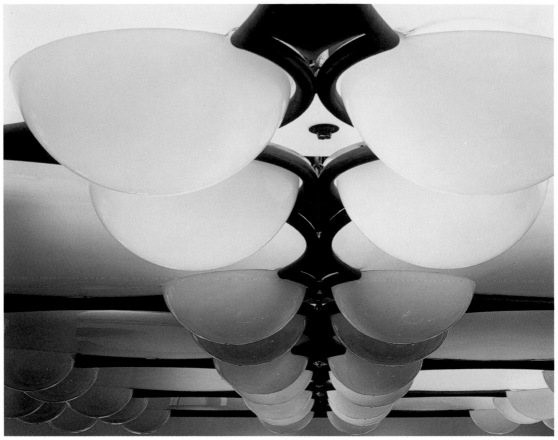

V.C. Morris Gift Shop

A building game, developed by Friedrich Froebel (1782-1852), was very important in Frank Lloyd Wright's training, and he said so throughout his life. The game consisted of a set of small blocks in regular shapes, from which different shapes could be created, always based on the repetition of a single module. The rationality of these blocks would seem to contrast with other statements by the architect, who saw his great source of inspiration in nature. But, to the architect, both nature and the building game of his childhood were part of the same world, since the rational shapes of any pure volume can be broken down into less regular shapes, and vice versa. To him, simple shapes could be understood just by looking at them, even if the building had a portico with recesses and projections or with pillars whose slenderest part was at the base.

Wright, who never wanted to belong to any specific architectural school or trend, did feel close to the word organicism. Although he never liked labels and was always interested in constant innovation as the opportunity arose, it is also true that the idea of his architecture as an extension of nature did not displease him. What interested him was making houses habitable and comfortable, enabling the

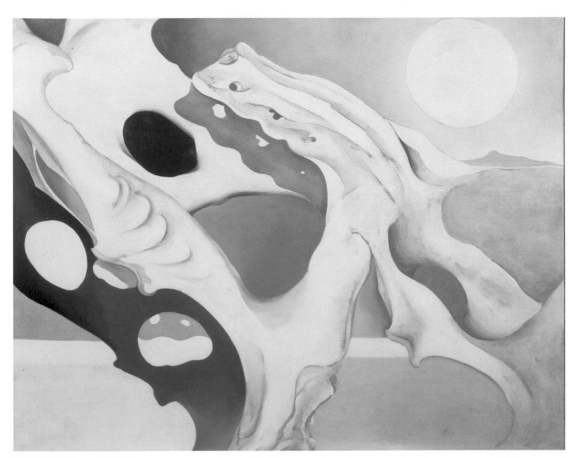

Pelvis with Shadows and the Moon
1943. Oil on canvas (40 x 48 inches)

residents to develop as people and as a community. And for that, Wright considered contact with nature indispensable. The mix of ideas about a life in the midst of nature, constant innovation with new materials, the memory of the pure shapes of his childhood toys, and especially, his expansive imagination, make many of his buildings seem almost like great, habitable sculptures. In them, windows or pieces of furniture in the most improbable shapes are juxtaposed with a simple wall or a large tree from the garden. And what is perhaps most remarkable is the total harmony of construction with shapes that are surprising because of their uniqueness

and perfect integration with their natural or man-made surroundings.

Georgia O'Keeffe flirted with abstract art throughout various periods of her artistic life, but never abandoned the representational world. As a painter, she was interested in the abstraction existing in natural shapes, but never to the point of abstraction in and of itself. Even her most abstract paintings have a real object as their basis and there are very few abstract pieces in her work. One of them is entitled, precisely, *Abstraction* (1946), and, done in clay, it is one of her few sculptures. The clarity of its lines, despite its being an abstract figure, and its resem-

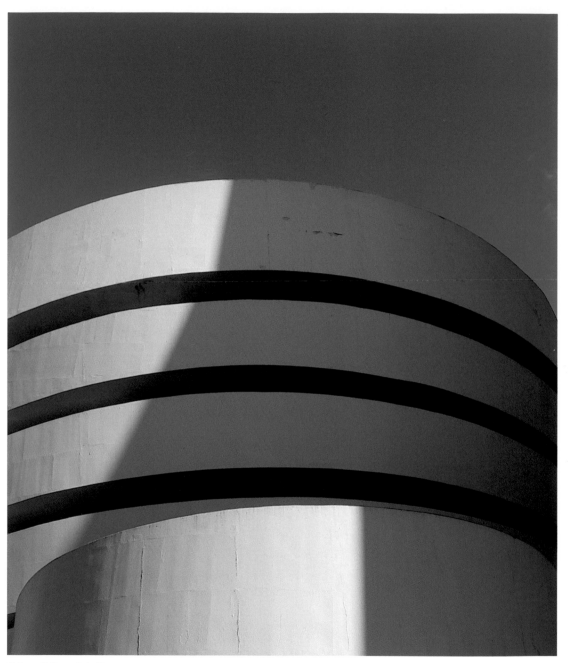

Solomon R. Guggenheim Museum

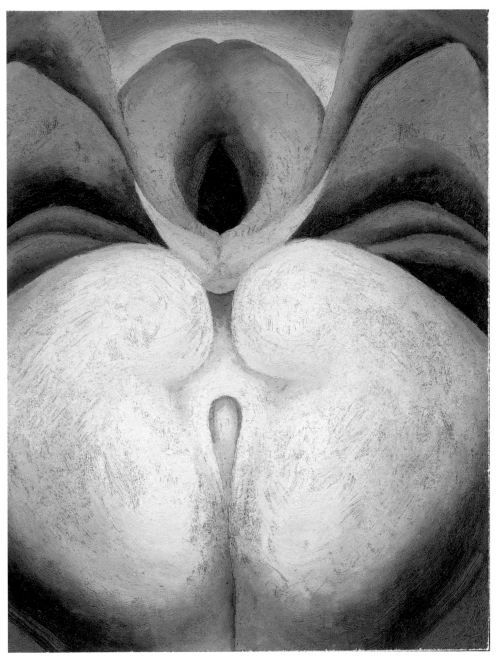

Series I White and Blue Flower Shapes
1919. Oil on board (19 $^{7/8}$ x 15 $^{3/4}$ inches)

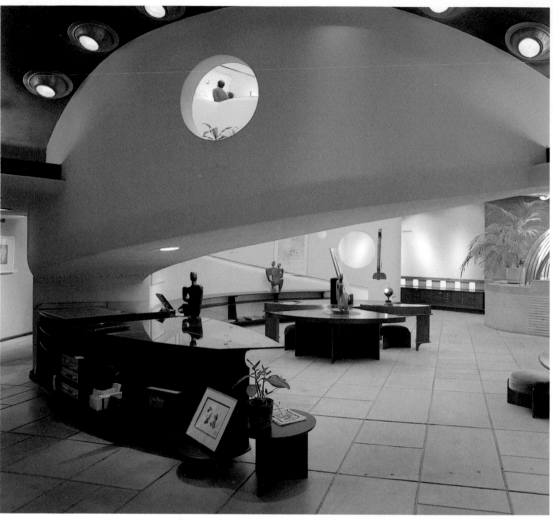

V.C. Morris Gift Shop

blance to the natural world, are striking. The sculpture represents a seashell or a conch, referring also to a living being, or to its movement. Despite the fact that it is very difficult to establish a direct similarity to a real object, it is a sculpture that seems to be part of the natural world.

The window at the top of the ramp in the V.C. Morris Gift Shop creates a visual relationship between the shop's upper and lower floors. With this very simple, round interior window, Wright creates a highly unusual perspective, connecting the ramp with various points of the lower floor.

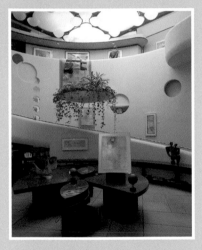

The circular ramp that connects the two floors is the central element of the shop. Wright used the high space that opens up in the middle of the ramp to hang panels from cables, on which he placed small plants and lights. Although these elements may seem superfluous, they are perfectly functional, as are the rest of the furnishings.

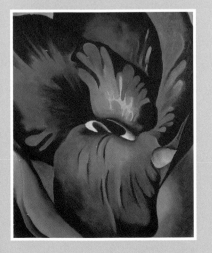

Canna, Red and Orange, 1926, Oil on canvas, (20 x 16 inches). In many of O'Keeffe's works, like *Cannes, Red and Orange,* it is difficult to recognize the subject at a glance. The color and the abstract shapes are the first things one notices, before recognizing the subject of the composition. This interest in seeing and highlighting shapes in natural objects is evident in most of her subjects, whether a series of flowers, or bones, or even in many landscapes.

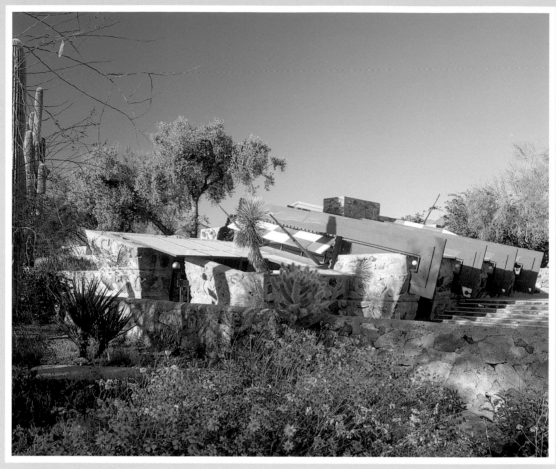

Taliesin West

THE MYTH OF THE WEST

Living in the Desert

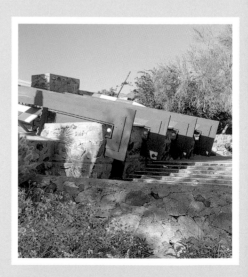

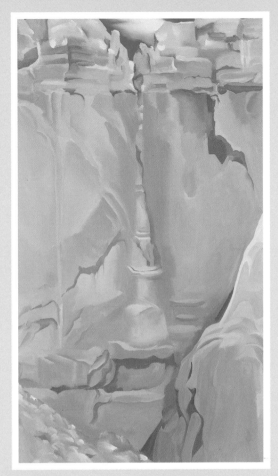

Part of the Cliff
1946. Oil on canvas (36 x 20 inches)

Both Wright and O'Keeffe lived much of their lives in the desert of Arizona and New Mexico, far from the country's great capital cities. The dryness of the mountains, bereft of plant life, contrasts with the vitality and delicacy of the flowers, both themes painted by O'Keeffe. The same contrast is apparent in Wright's work: the hardness of the Taliesin West's exterior contrasts with the softness of the interior fountain and small garden.

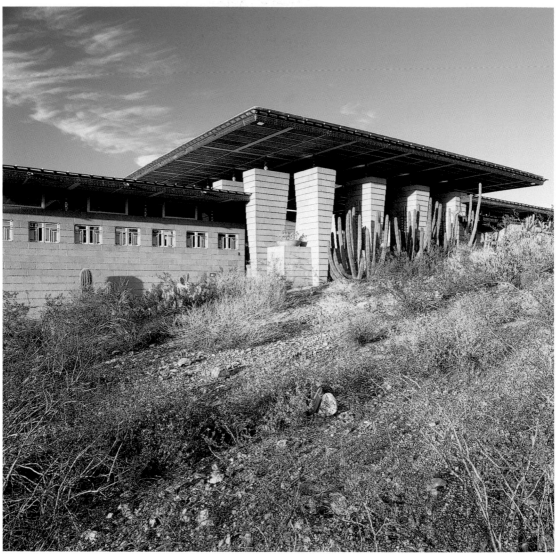

H.C. Price House

The deserts of the American Midwest are the crossroads of several vastly different areas: to the south, Mexico; to the north, the Great Plains; and to the east and west, the coasts, so individual and different. But despite being a transition area, it is an important territory in its own right. It is also the site of the most famous part of the conquest of the West, and, although it was a relatively brief period of time, it has become part of modern mythology. The painting known as *Cow's Skull — Red, White and Blue* (1931) is a fine representation of this myth, exalting one of its symbols: the somber skull of a dead cow stands out against the colors of

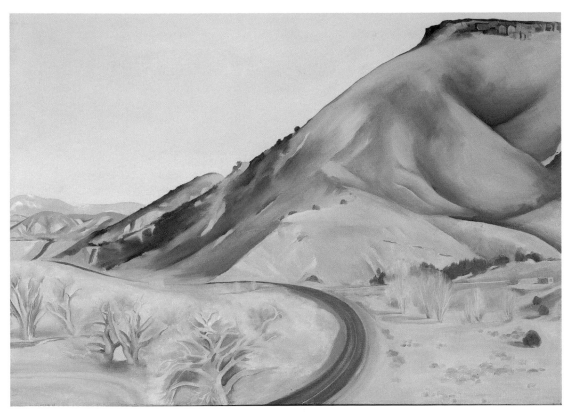

Mesa and Road East II
1952. Oil on canvas (26 x 36 inches)

the American flag. With a very simple composition, O'Keeffe touches the depths of the American unconscious, using a very powerful pop culture icon and incorporating it fully into the country's pictorial and symbolic tradition.

Both Wright and O'Keeffe lived the final years of their lives in this territory, not as a way of separating themselves from the world, but engaging with it: she painting great masterpieces and he designing many buildings in his studio. And both adapted, little by little, to the climate and territory: Wright, in the early years, lived in Taliesin West only during the winter, fleeing the harsh Wisconsin climate; O'Keeffe lived in Abiquiu only during the summer, returning to New York in the winter, or making brief trips to Lake George.

This slow adaptation to the territory, shared by the two artists, left its mark on them. What for the architect was, at first, almost a requirement for his health, became, over time, a new dream and, as in all his houses, there was almost always some remodeling or expansion going on. His relationship with the desert landscape would never be as deep as his relationship with Taliesin East, where he had spent his formative years, and the lands that had seen his Welsh ancestors grow up. But even so, what Wright needed was contact with wide-open spaces, with nature. And like his building, he adapted to the new situation and learned to flourish in it. To mitigate the sharp temperature changes, with high heat in the morning and very low temperatures at night,

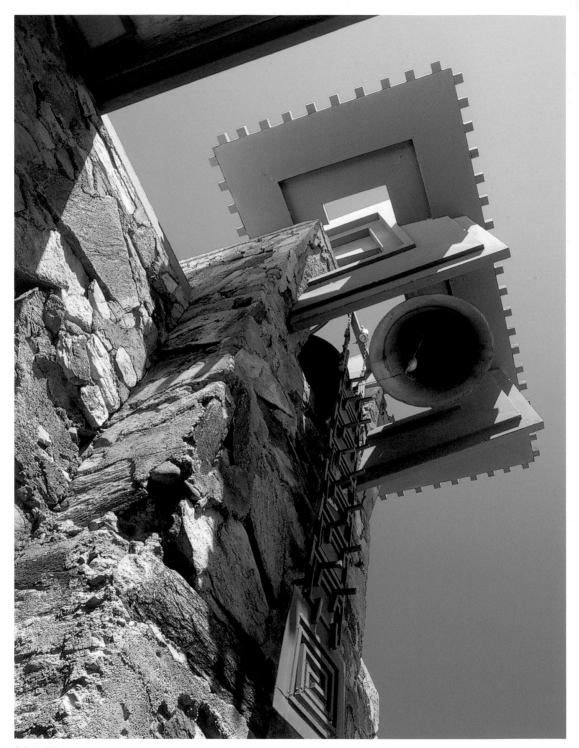

Taliesin West

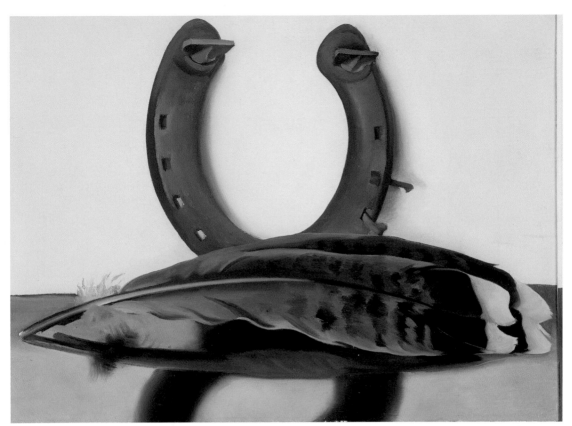

Turkey Feather with Horseshoe, II
1935. Oil on canvas (12 ¹⁄₈ x 16 inches)

Wright designed the building to be half buried in the sand, so that the interior would be below ground level, since just a few inches in the desert mean an enormous temperature difference. And Wright learned to live in these new circumstances, surrounded by a group of students who worked for him while learning from a teacher who was already admired by architects of the stature of Mies van der Rohe.

The relationship between O'Keeffe and the desert was vastly different. To the painter, Abiquiu and its surroundings were one of the most authentic settings on earth. She felt very close to the natural setting, to the point of saying that even after death her spirit would continue to watch over that land which had received her so well, in keeping with local Native American custom. On it she found herself at home, and it was the best studio any painter could want: an open-air space in which every day the landscape was an inspiration. Georgia O'Keeffe decided to go and live permanently at Abiquiu and Ghost Ranch after her husband's death in 1946. As in Wright's case, it was a deci-

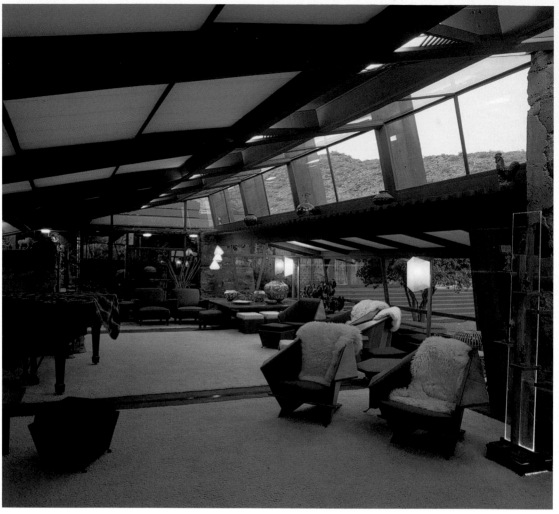

Taliesin West

sion that enabled her to start a new stage of life, which, without forgetting the one that came before, was necessary to keep her motivated. During the last phase of her life, when she had lost her eyesight and been forced to lay down her paint-brushes, Georgia O'Keeffe continued to feel very close to her home, and, while she could neither see nor paint it, she did make pottery for a time, in keeping with Native American custom.

The great windows of Taliesin West open onto a terrace and a splendid landscape. Because of their orientation, they get direct sunlight only in the afternoon, when the heat is less intense. Also, the large windows are divided into upper and lower banks; precisely mitigating temperature increases without decreasing light or visibility.

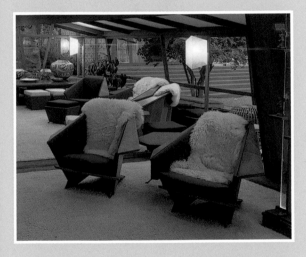

Taliesin West is equipped for the hot mornings and cold nights of the desert. The sheepskins not only pad the chairs but also insulate, especially against the cold. The entire building takes the region's great temperature variations into consideration in order to make life in this environment more livable and comfortable.

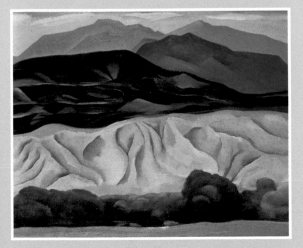

Outback of Marie's I, 1930, Oil on canvas, (20 x 24 inches). There is hardly ever a sign of human beings in O'Keeffe's landscapes. The vista alone is their strength. In contrast to picturesqueness, in which the landscape is constructed with natural elements from different places, or simply invented, O'Keeffe wanted to capture a specific place, its essence, and she was always true to the reality she saw. The strong sun and the sharp changes in the desert light make the colors quite vibrant. Her being in such a setting was the best thing that could happen to her, since the chromatic intensity of such a stark landscape fascinated her.

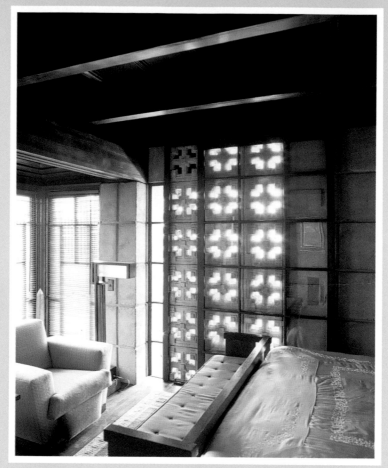

Storer House

FAR FROM EUROPE

A new tradition

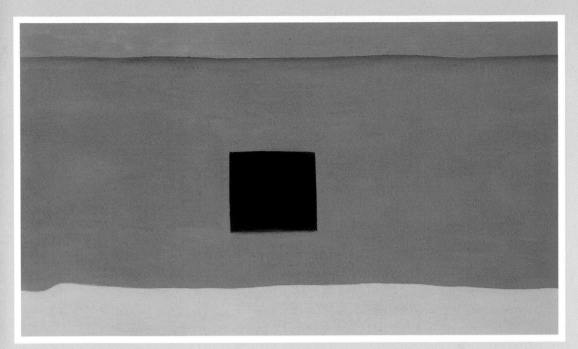

In the Patio, III
1948. Oil on canvas (18 x 30 inches)

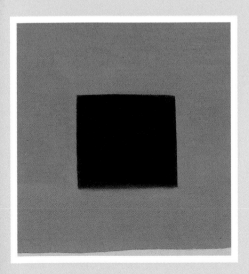

Frank Lloyd Wright maintained a close relationship with the Japanese culture, which was fundamental for the development of the spatial concept of his work. Wright always showed a great interest in different architectural traditions, from the babylonic ziggurats present in the Guggenheim, to the Arab latticework found in the Storer house. The Far East had an equally strong influence on the work of Georgia O'Keeffe, particularly in the treatment of colors and the simplicity and purity used to represent volumes and space.

Hanna Residence

The creation of vast interiors with few partitions separating the spaces for daily activities is one of the most important innovations introduced by Frank Lloyd Wright, starting with the first of the Prairie Houses, the Winslow House (1893-1894). A year before starting this project he visited the reconstruction of a Japanese temple at the Columbian Exhibition (Chicago). It was then that he became interested in this culture, which struck him as immensely rich, and began a collection of Japanese art and books on Japanese culture. Under the influence of what was, to him, a new architecture, he began designing much bigger interior spaces, forcing him to solve various technical problems. Until that time, the walls of houses helped support the roof. But, his desire to open up large windows and minimize the division of the interior space could cause structural problems. So Wright adapted the use of the reinforced concrete and iron beams found in the large Chicago buildings he

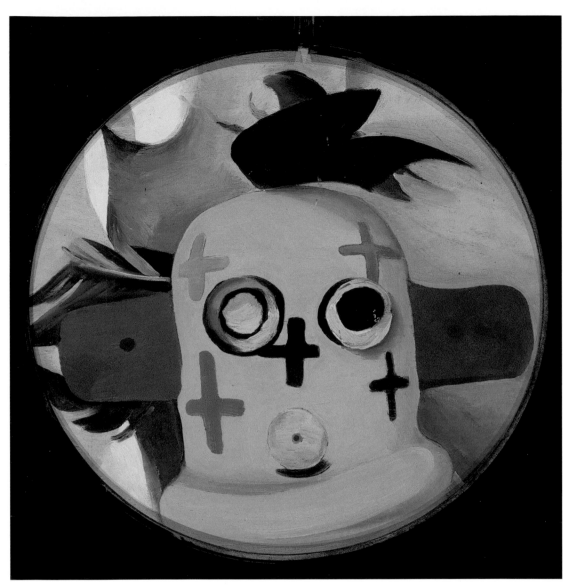

Paul's Kachina
1931. Oil on Board (8 diameter)

learned about when working with Sullivan, to these single-family, two-story homes. He began to work with beams and columns to support the roofs, in order to have much more freedom in distributing the spaces and walls. The Japanese influence grew as he spent long periods in Japan building the Imperial Hotel (1915-1923), which would be greatly admired in the island country and only a small part of which remains today. Despite his popularity in Japan, only three of the six buildings he erected there remain.

In addition to the Far Eastern influence, Wright did not hesitate to assimilate construction techniques and solutions from very different traditions. The "textile blocks," a technical experiment in construction with prefabricated concrete blocks, with which he built structures as famous as the Storrer house (1923), have their formal roots in Arabic latticework; and the inverted spiral of the Solomon R. Guggenheim Museum in New York is

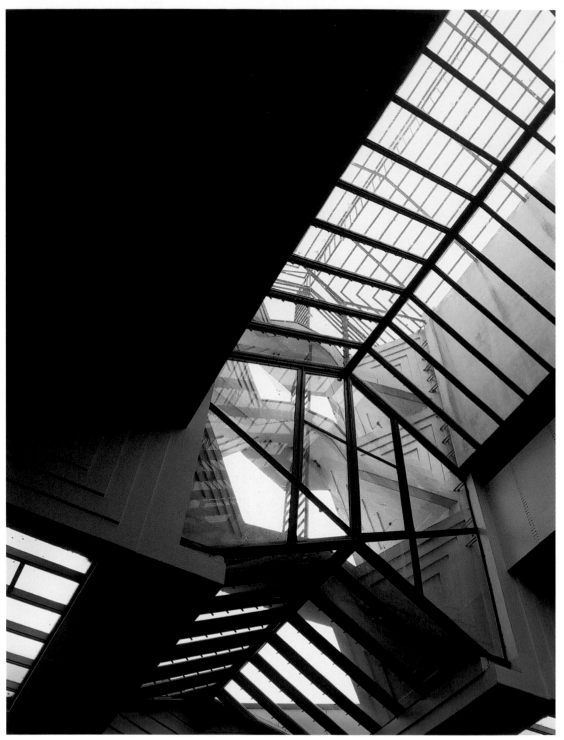

Florida Southern College

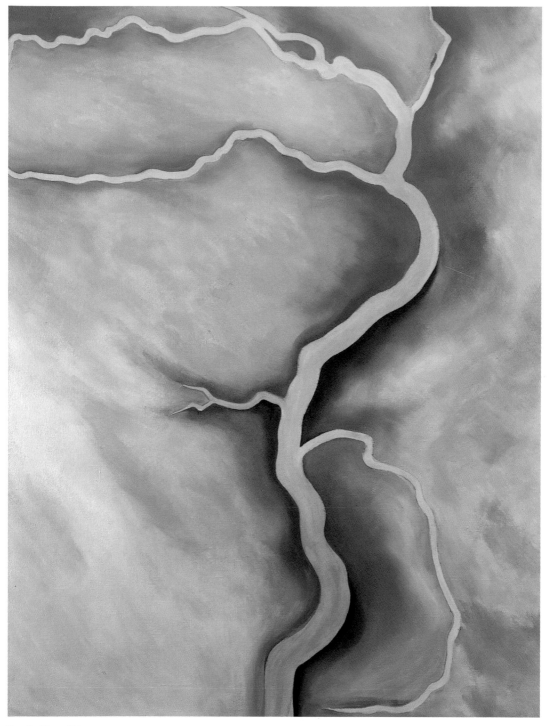

From the River — Pale
1959. Oil on canvas (41 ¹/₂ x 31 ³/₈ inches)

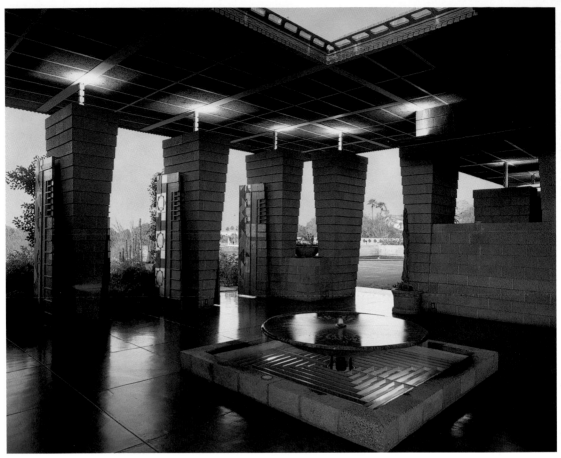

H. C. Price House

descended from the ancient Babylonian ziggurats, a form Wright liked very much and which he wanted to use for his Baghdad Opera project in 1957.

Knowledge of Chinese and Japanese aesthetics was pivotal to the oeuvre of Georgia O'Keeffe, who based some of her synthesis and refinement work on the traditional Japanese system of lights and darks known as notan, and who was always interested in the oriental pictorial tradition. The painter's knowledge of Japanese aesthetics was not as direct as

Wright's, but she studied in a milieu in which the Chinese and Japanese cultures were admired. Artist, designer, and teacher Arthur Wesley Dow encouraged his students to become familiar with the artistic traditions of different cultures, and recommended Ernest Fenollosa's book, *Epochs of Chinese and Japanese Art* (1912), to O'Keeffe. This work, which is basic to an understanding of the spread of Eastern aesthetic ideas in the United States, also influenced poet Ezra Pound (1885-1972) and others.

In Western tradition, the relationship between the supporting elements and roofs has to be visible and clear. However, in Japanese construction tradition, it is normal to find supports that do not directly sustain the entire roof, but rather, a central strut of the column itself performs this function. Wright used this device in several structures, such as this interior garden of the H. C. Price House (1954). The movable walls between the columns are very typical of the architect, since they make it possible to completely transform the garden's appearance in just a few minutes: from an indoor garden when the screens are closed to an outdoor garden when they are open.

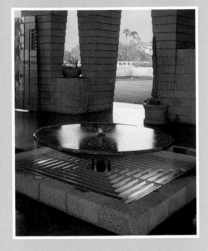

The large central fountain in the middle of an arcaded courtyard is one of the best-known features of Mediterranean architecture, widely used in both Greco-Roman and Arabic architecture as well as in later eras. The unadorned circular fountain, partly accessible at floor level, is reminiscent of Arabic fountains, as is the placement of the courtyard, which is important in and of itself and not subordinate to any other space.

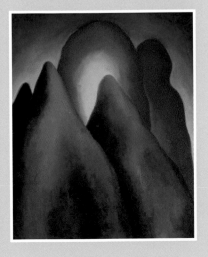

Anything, 1916, Oil on board (20 x 15 ¾ inches). In the artist's early work the importance of color dominates the painting. But the search for a synthesis, for simplicity in the shapes, is indicative of an effort to capture the landscape in a manner totally different from the merely realistic. Although Kandinsky's experiments had a strong influence on O'Keeffe, she was never interested in achieving a total abstraction, but always maintained a link to realism.

Georgia O'Keeffe 1887 - 1986

Georgia O'Keeffe is one of the most important and influential painters of twentieth century America, both because of how innovative her painting was in the 1920s to the small circle of contemporary art collectors and specialists and because of the general public's interest in her work, especially since the 1970s, when the country's most important museums held major retrospectives of her work. While her best-known paintings are the large canvases with flowers represented extremely close up, to the point that their shapes are closer to abstract painting than real life, her work includes various subjects and interests that evolved over the years.

But there are some features which are common to most of her canvases, and that are characteristic of the novelty of her work at the time. O'Keeffe broke with the idea of scale and perspective typical of the Western pictorial principles when she represented objects at very close range and in a setting without reference points. Moreover, many of her landscapes seem, on the face of it, to be abstract paintings, with lines and colors that faintly depict a landscape, but just barely recognizable. To O'Keeffe, the most suggestive and improbable shapes were in natural objects, and just by observing an object carefully one would come to marvel at the wonder of it.

Georgia O'Keeffe is considered one of the most important figures in American art, one of the "new classicals" of the twentieth century. Born in Sun Prairie, Wisconsin, in 1887. In 1905, after finishing high school, she enrolled in the Art Institute of Chicago, and two years later in the Art Students League, New York, where she began to question her own abilities, partly because no one took a woman who wanted to be a painter seriously. In 1908 she abandoned her classes in New York, returning to Chicago to work as a designer. She painted nothing for several years. But in 1912 she accepted a job in Amarillo, Texas as "supervisor of drawing" for the local public schools. This would change the course of her life. The vast Texas landscapes had a profound impact on her, while isolation helped clarify her thinking. Slowly she began to have ideas about painting, and began spending summers at the University of Virginia, where Professor Alon Bement (himself a student of Arthur Wesley Dow) showed her the possibilities inherent in the Eastern theories of art, such as notan, a traditional Japanese system of lights and darks in which simplicity reigns supreme. In 1914 she returned to New York to study with Arthur Wesley Dow (1857-1922) himself. In addition to completing her training there, she read *Epochs of Chinese and Japanese Art* (1912) by Ernest Fenollosa, a leading expert in Chinese and Japanese art and poetry, and became familiar with Eastern theories of aesthetics. After completing her studies, she was offered the opportunity to teach at Columbia College in South Carolina in late 1914, at which point she gave up teaching in Amarillo. The work at the college left her a great deal of

Part of the Clift
1946. Oil on canvas (36 x 20 inches)

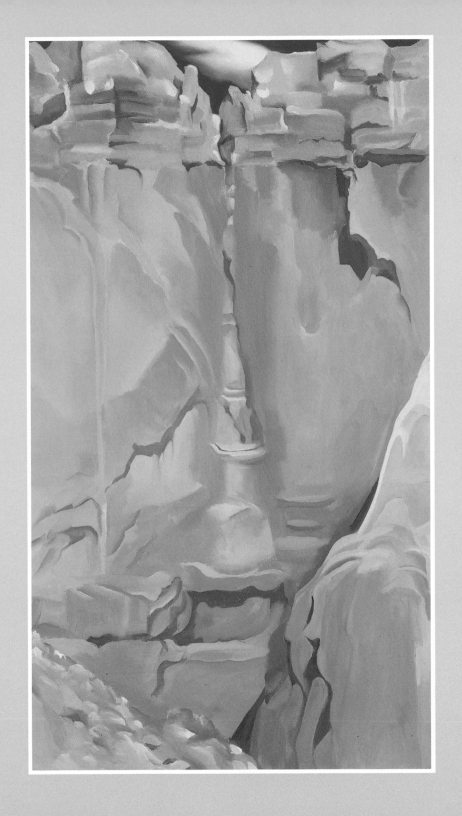

free time, and, with materials and a studio at her disposal, she resumed painting on a regular basis.

Two years later, her friend Anita Pollitzer showed Georgia O'Keeffe's drawings to Alfred Stieglitz (1864-1946), the photographer and art dealer who owned the 291 gallery, an icon to Georgia O'Keeffe and all the other modern painters in Manhattan. Although Stieglitz was at first interested but not overly-enthusiastic, in later years he would come to be her strongest supporter and champion, encouraging her to continue painting. By 1918 they solidified the relationship that had begun years earlier, living together, before Stieglitz was divorced from his wife, despite the scandal.

The Stieglitz family home at Lake George would, for many years, be the place where the couple spent most of their summers and a source of inspiration to the painter. In New York she would begin her flower paintings, which would make her famous and enable her to live on her earnings. She sold one of these in 1928 for $25,000.

By the late 1920s O'Keeffe wanted to return to Texas and get to know new places, but Stieglitz, at age 64, was less enthusiastic. Finally, O'Keeffe went without him in the summer of 1929 to Taos, New Mexico, where she was captivated by the landscape: the high skies, strong light, vivid colors, and dry atmosphere. She began painting works with desert themes and, from then on, returned to New Mexico every summer, exploring different areas on each trip. She bought a Model A Ford and, after learning to drive (not without difficulty), modified it for use as a small mobile studio so she could paint anywhere. In 1936 she made her first visit to Ghost Ranch, which became one of her favorite places. She bought a house there in 1940 and, five years later, another in Abiquiu; these would become her residences after Stieglitz's death in 1946.

She would spend the rest of her life at Ghost Ranch and Abiquiu, developing a very profound relationship with the territory and its traditions, and with her career as an artist solidified. In 1962 Georgia O'Keeffe was elected to be a member of the American Academy of Arts and Letters, the United States' highest honor for painters and writers.

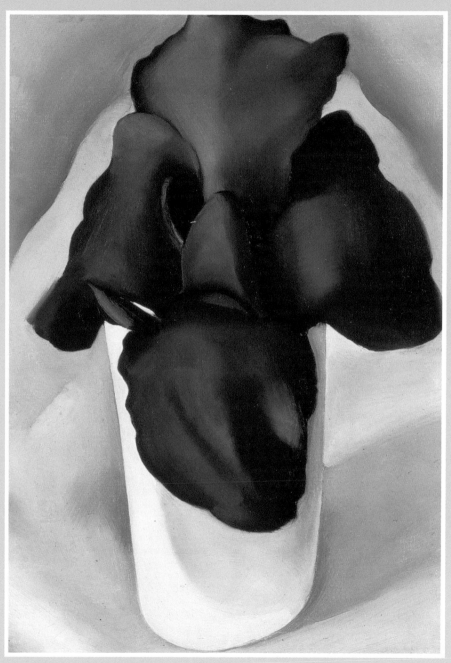

Untitled (Flower)
1928. Oil on canvas (10 $^{1/8}$ x 7 $^{1/8}$ inches)

RED LANDSCAPE

1916-1917. Oil on board (24 $^{1/2}$ x 18 $^{1/2}$ inches)

Red Landscape and *Anything* are two oils that show the artist's interest in the landscape dating back to the very beginnings of her career, and her unique point of view.

Georgia O'Keeffe knew, from childhood on, of her great perceptive ability, being able to appreciate the subtle chromatic changes in a single flower, while people around her could not see these small differences that were so beautiful to her. This ability to observe was very important to her work method since, when she studied an object closely she often wanted to paint it and, in doing so, perceive it much more acutely. In addition to this keen perception, the training in oriental art and the theoretical texts of Vasily Kandinsky (*Concerning the Spiritual in Art*, 1910) on internalizing nature in order to express the artist's emotions through it, led her, around the middle of the second decade of the twentieth century, to a very individual type of painting that already hinted at the great landscapes to come. Spatial abstraction and refined shapes in simple volumes, characteristic of O'Keeffe, are already apparent in these works, although the true protagonists are the colors. In both *Red Landscape* and *Anything* the first thing that jumps out at the viewer is the vibrancy of the colors, with the combination of two opposites, red and green, dominating. The impressionists in the late nineteenth century, also in a search for an art with more refined shapes explored these combinations.

Anything
1916. Oil on board (20 x15 3/4 inches)

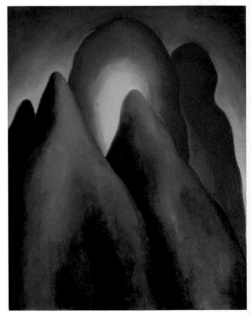

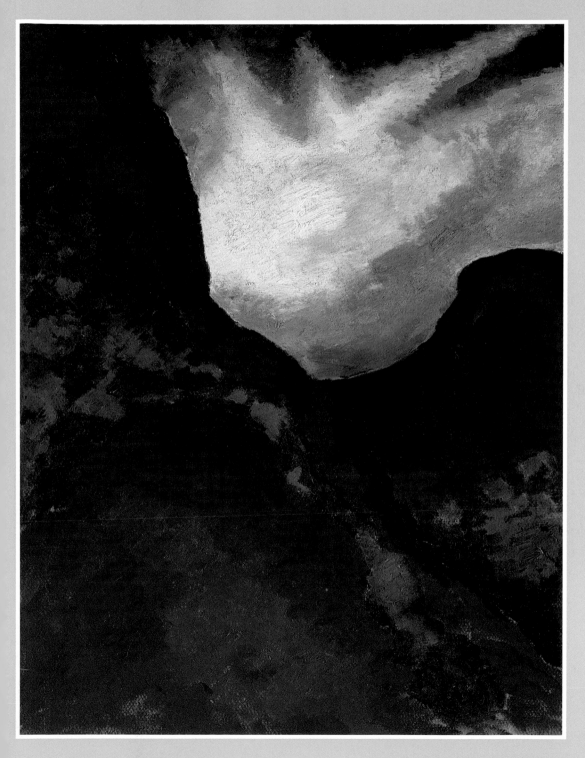

SERIES I WHITE AND BLUE FLOWER SHAPES

1919. Oil on board (19 7/8 x 15 3/4 inches)

As far back as her early youth, when being a painter was still a far-off dream, O'Keeffe was already thinking about painting things close to people, part of their normal environment. And one of the objects in this everyday environment that most fascinated her was the flower, paintings of which would make her famous years later. O'Keeffe's flowers are very important in the history of art because of the novel way in which she represented them: as lone objects, in a pictorial space that did not respect the classic laws of perspective. But they also represent one of the first examples of the triumph of a theme that would be characteristic of American painting and art: the ability to consider an everyday, seemingly banal reality worthy of artistic treatment. What is fascinating about O'Keeffe is her ability to make each of the flowers she painted special, to understand nature through a simple flower, and to portray what seems to us to be the essence of that specific flower in all its complexity.

From the late 1920s on, when Georgia O'Keeffe was featured in various exhibitions at the 291 gallery, her flowers came to be admired. The sensuality of her paintings caused a bit of a stir when the flowers were interpreted as a portrayal of female genitalia. Stieglitz, her art dealer, with whom she would become involved in a long-term relationship, never denied the resemblance, knowing that in the world of art, a little scandal was always advantageous. The series of Stieglitz' portraits of O'Keeffe, many nude, helped to create a certain myth about the couple regarding their failure to respect the social taboos of the time and portraying Georgia O'Keeffe as a fascinating creative talent, both artist and muse.

Georgia O'Keeffe devoted herself to the portrayal of flowers and the vast world they contained, even though her abstractions and paintings of flowers lent themselves to interpretation in sexual terms, and the pseudo-Freudian interpretation fashionable at the time.

Untitled (Poppies)
1926. Oil on canvas (6 x 8 inches)

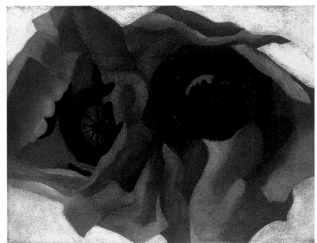

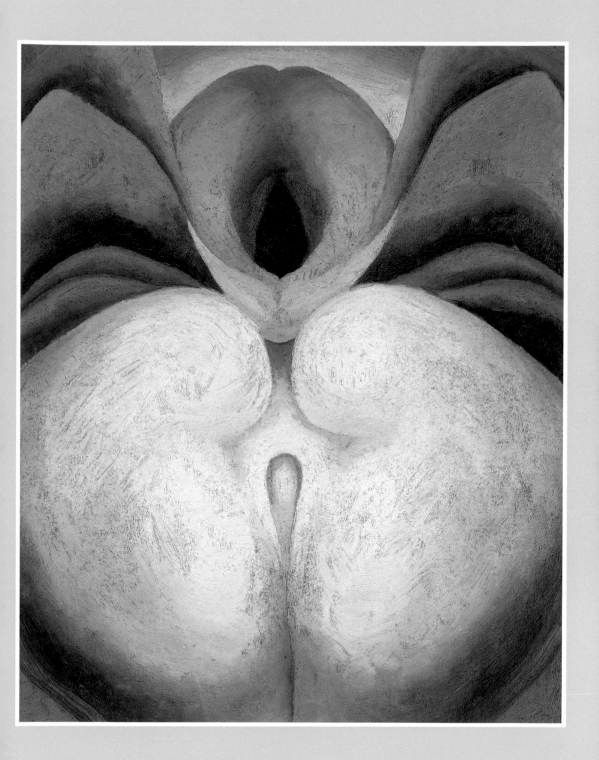

MY AUTUMN

1929. Oil on canvas (40 x 30 inches)

In addition to the flower series, Georgia O'Keeffe painted many leaves during the late 1920s and the 1930s, concerned with making each of these objects unique and delighting in the chromatic range and intensity of the colors. In the years during which she began to frequent the Stieglitz family's Lake George home, she based many paintings on its luxuriant landscapes and natural setting. It was there that she began collecting leaves on her walks, to paint them later on in the house, until they became another pictorial theme.

One of the first things that surprise the viewer of these works is their larger-than-life size. Thus enlarged, the leaf becomes an impressive object, with its capricious shapes and its color. To emphasize this change of scale even more, O'Keeffe created two distinct types of representations of leaves: she painted absolutely solitary leaves on neutral backgrounds, with the object and its uniqueness highly prominent, and she also painted a cluster of leaves, emphasizing their capriciousness as a group, with shapes that were sometimes bordering on the abstract or that were similar to a flower's petals.

Slowly, and starting with the increasingly frequent trips to the Texas desert, Georgia O'Keeffe abandoned the leaf theme and focused more on the desert and the bones of desert animals, another natural form that triggered her imagination and creative energy.

Oak Leaves
1923. Oil on board (10 x 7 $^{1/2}$ inches)

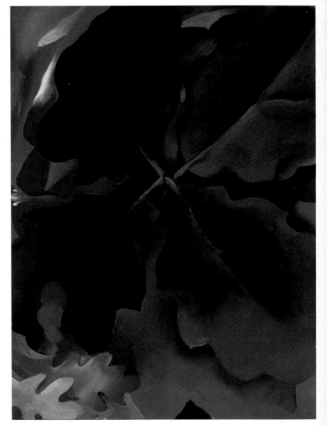

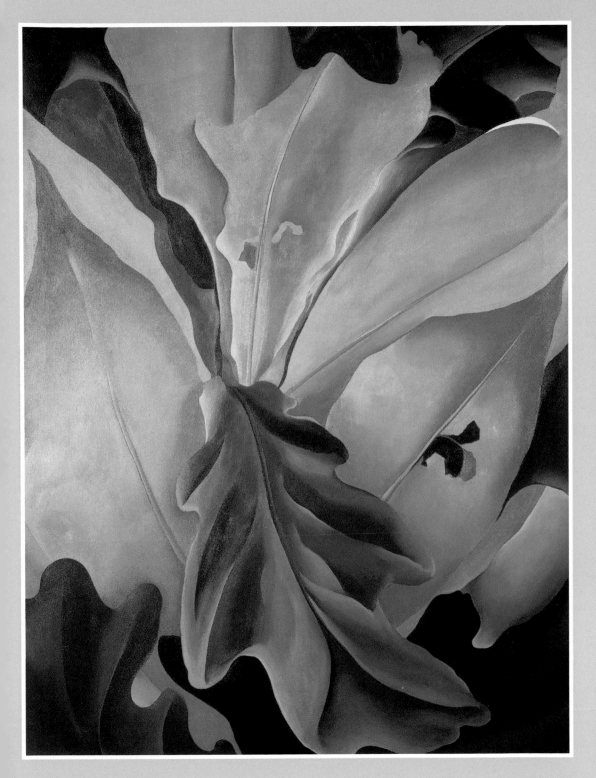

EAST RIVER, NEW YORK II

1927. Pastel on paper (11 $^{1/4}$ x 28 $^{1/2}$ inches)

In 1925, Georgia O'Keeffe and Alfred Stieglitz moved to an apartment on the thirtieth floor of the Shelton Hotel, with a spectacular view of the city. Here she painted the urban landscape, and here began her interest in the city as a subject, which, along with the large flower paintings, would be central to her work between 1925 and 1929.

In some of these paintings she adhered to the precisionism practiced at that time by painters Charles Sheeler (also a photographer) and Charles Demuth, acquaintances of Stieglitz. But photography did not carry as much weight for O'Keeffe, who was more interested in capturing the light and space than in reality and the new tool, photography. In *East River, New York No. II*, she created the sensation of depth with three horizontal bands: the industrial buildings and the streets are recognizable in the first dark band, silhouetting the skyline against the light blue of the river. The other bank, in the background, is just a barely-defined mass on which only a few industrial elements are recognizable, framing the upper part of the composition. Thus, the river becomes a band, touched by the light (light blue, white tones, and hints of yellow), cutting across the dark, shapeless city. Despite the painting's realism, O'Keeffe's approach reveals an interest in the abstract shapes beneath every image of reality.

In the urban landscapes painted from the Shelton and other works produced during this period, the human figure never appears. Similarly, the pictorial work of Sheeler and Demuth almost never shows citizens amid the factories and buildings. These pieces, together with the work of Edward Hooper (1882-1967), created a powerful image of the American city, with a tradition all its own, in which solitude and nostalgia are part of the urban world.

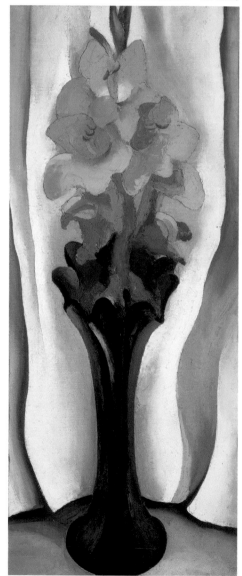

Pink Gladiolus
1920. Oil on canvas (24 $^{1/8}$ x 10 inches)

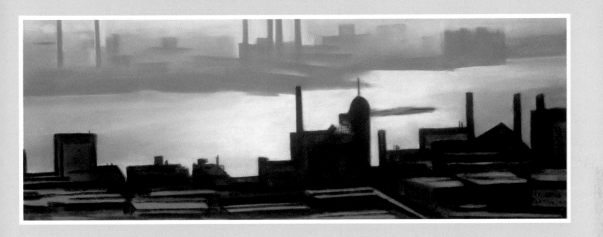

COW'S SKULL—RED, WHITE AND BLUE

1931. Oil on canvas (39 $^{7/8}$ x 35 $^{7/8}$ inches)

In 1930, during Georgia O'Keeffe's second summer in New Mexico, she began collecting the bones of dead animals in the desert. Having returned to Lake George, fascinated by their shapes, she decided first to draw them and then to introduce them into her paintings, in what would become, along with flowers, one of the subjects most representative of her work.

In the earlier paintings she concentrated on capturing the realistic shapes of a cow's or burro's skull, and was more interested in depicting the richness of their actual forms than their possible connections to abstract shapes. Later she would develop an interest in the relationship between the bones and abstraction, when she painted close-up views of the hip and other animal bones whose shapes are not directly recognized – a method she also experimented with in painting flowers.

Georgia O'Keeffe had two basic interests that allow for a certain classification of her work. Firstly, she was very interested in objects, and said that when painting an object she had to focus her attention on it and discover it little by little. Secondly, O'Keeffe was also inspired by open space (treated with the same desire to capture reality as is evident in the small objects), which was the motivation behind her landscapes of the Lake George area, the Texas desert, and even her urban landscapes.

The space in which the animal remains are portrayed is often very difficult to recognize. *Cow's Skull — Red, White, and Blue* is a clear example. While the skull is treated with a precisionist realism, its setting is very difficult to pin down. The great drama of this work is not achieved through the composition alone (in which the centrality of the skull is emphasized not just by the chiaroscuro and the blue lines), but also by the colors of the American flag and the cow's head, mythical symbols of the country and the Wild West.

Pelvis with Shadows and the Moon
1943. Oil on canvas (40 x 48 $^{3/4}$ inches)

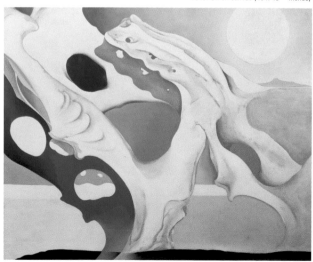

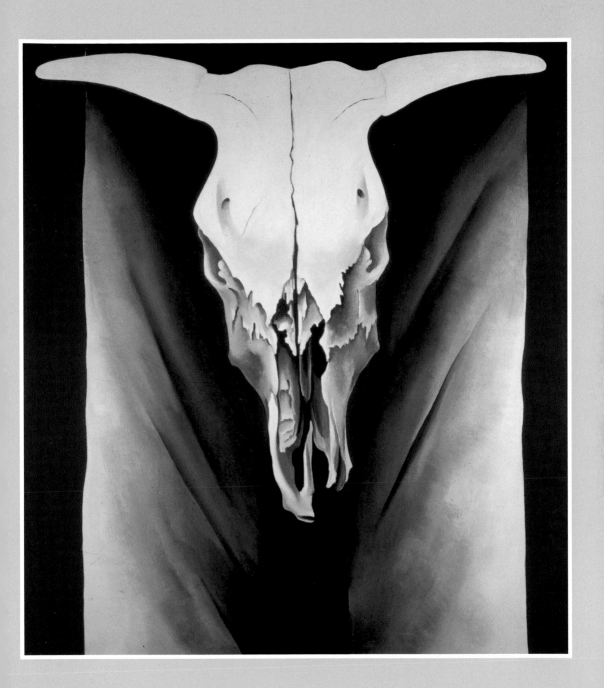

OUTBACK OF MARIE'S I

1930. Oil on canvas (20 x 24 inches)

The landscapes near Abiquiu and Ghost Ranch became some of Georgia O'Keeffe's favorite subjects as she spent more and more time in the desert. When she came to Taos, New Mexico, in 1929, the landscape fascinated her, as it had on her first trip to Amarillo in 1914. The long trips she took enabled her to enjoy the setting, but only allowed her to make some sketches on a small writing pad, when what she really wanted was to paint with oils out in the open air. For that she had to be able to drive a car, so she could go wherever she wanted and not depend on anyone to take her. So, on one of her trips she bought an old Model A Ford, which she converted to a small mobile studio. The freedom to go wherever she wanted without depending on anyone was a great triumph for her, after difficult driving lessons and with few people understanding why a woman wanted to venture alone into such harsh territory with just canvas and paint. In this way the painter could move through a dream setting, almost as if traveling through one of her paintings.

During the first years in New Mexico, each painting represented a new landscape, a new gradation of colors, a different kind of light. But over the years, O'Keeffe began to repeat the same landscapes in different seasons. In *My Front Yard, Summer*, the artist painted the view from her studio. But in the spring, less than a year later, she repeated the same scene, with the change of vegetation, light, and tones. Far from an experiment on the effect of light on objects and color, as conducted by the French impressionists, O'Keeffe's work stems more from the fascination with the landscape itself and its many variations.

My front Yard, Summer
1941. Oil on canvas (20 x 30 inches)

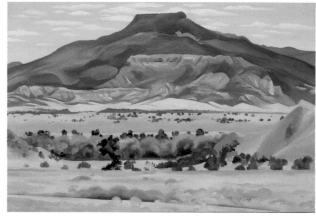

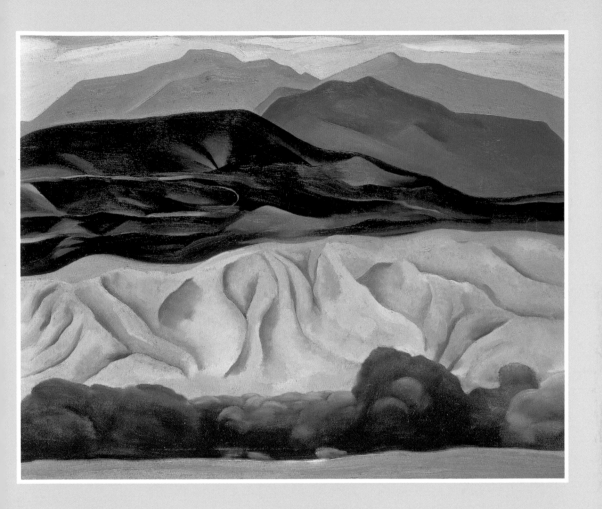

PAUL'S KACHINA

1931. Oil on board (8 inches in diameter)

Kachina are dolls made by most of the native tribes of present-day Arizona and New Mexico; those made by the Hopi are perhaps the most famous. They represent mythological figures, with characteristics that are echoed in the Native American ritual dances. During the first summers she spent in New Mexico, Georgia O'Keeffe attended several ritual dances and gradually became familiar with the indigenous and Hispanic cultures and the similarities between them.

The painter was strongly attracted to the Kachina. She found in them two apparently contradictory ideas: the calm and serenity of an inanimate object, but also the animation of a living being, since they represent mythological beings and incarnations of natural forces. While this is not a common theme in her work, it shows the extent to which it was related to the indigenous traditions. To the artist, Abiquiu represented not just a place where she could retreat from the world but, quite the contrary: growing closer to a more authentic culture and contact with nature enabled the artist to live as she wished and to continue painting only what interested her.

Paul's Kachina is one of her few paintings with a round frame, and formally it is a precisionist painting interested in capturing the essence of the object that is represented.

A Man From the Desert
1941. Oil on canvas (16 x 7 inches)

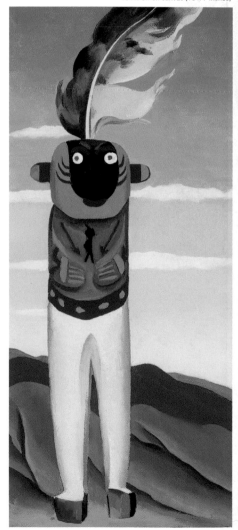

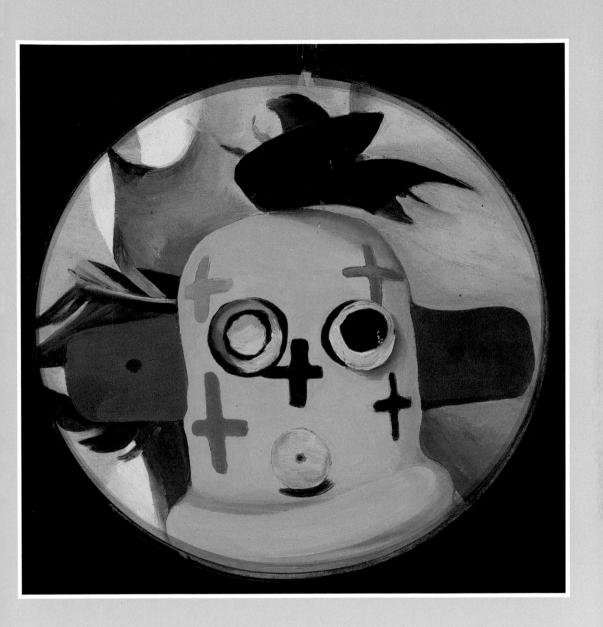

DEAD PIÑION TREE

1943. Oil on canvas (40 x 30 inches)

Georgia O'Keeffe used to say that when she painted a tree, she was a tree. This idea of communion with the represented object, of feeling like the painted object in order to capture its essence, has its roots in the lessons of Arthur Wesley Dow and in her readings on Japanese aesthetics. Kandinsky's text, Concerning the Spiritual in Art, is also basic to understanding this quasi-sacred relationship, in the act of painting, between painter and setting.

After moving permanently to New Mexico, O'Keeffe repeatedly used various trees as the subjects of her paintings in a very novel way, although it was a common theme in landscape painting. This interest had been present as far back as the 1920s, since she first became familiar with the Lake George area, when she painted its lush forests and the leaves she collected there. Georgia O'Keeffe was able to personalize the elements of the now famous leaves and flowers until their images seemed human: a distinctive characteristic of her work. In Tree With Cut Limb (1920), O'Keeffe painted a tree all in shades of green, with a prominent brown line indicating a cut branch. With a single, very simple touch, the title of the work becomes an overwhelming reality, and the cut becomes a wound that is out of sync with the rest of the painting's harmony. In Dead Piñion Tree, the presence of the dried-up tree inhabits the painting as a quasi-human shape, as if it were a portrait of a person and not a tree.

This ability to create sensations through trees and flowers, much admired in O'Keeffe, is the result of her skill in capturing the essence of the subject, its most significant features, regardless of the degree of realism or simplicity she gives to her work.

Cottonwoods Near Abiquiu
1954. Oil on canvas (22 x 26 inches)

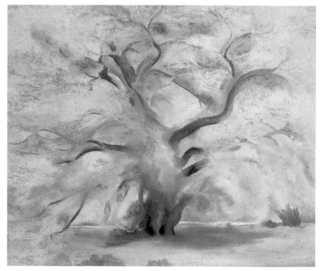

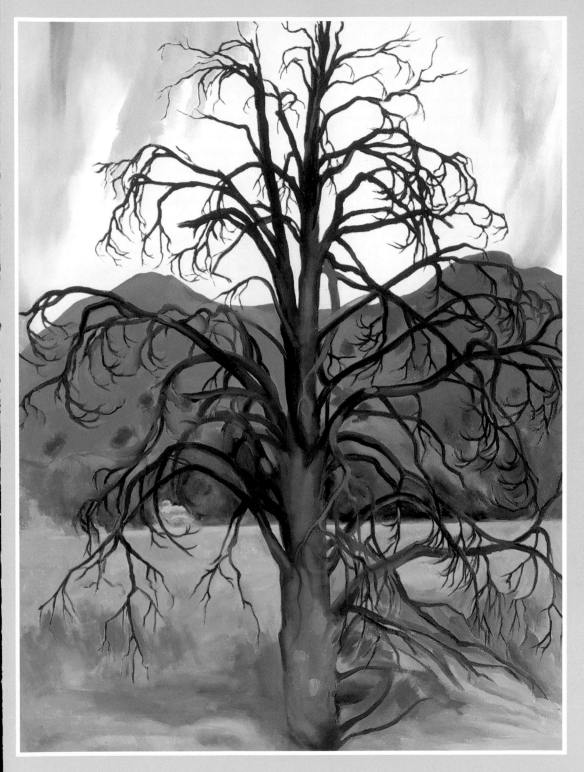

LIST OF IMAGES

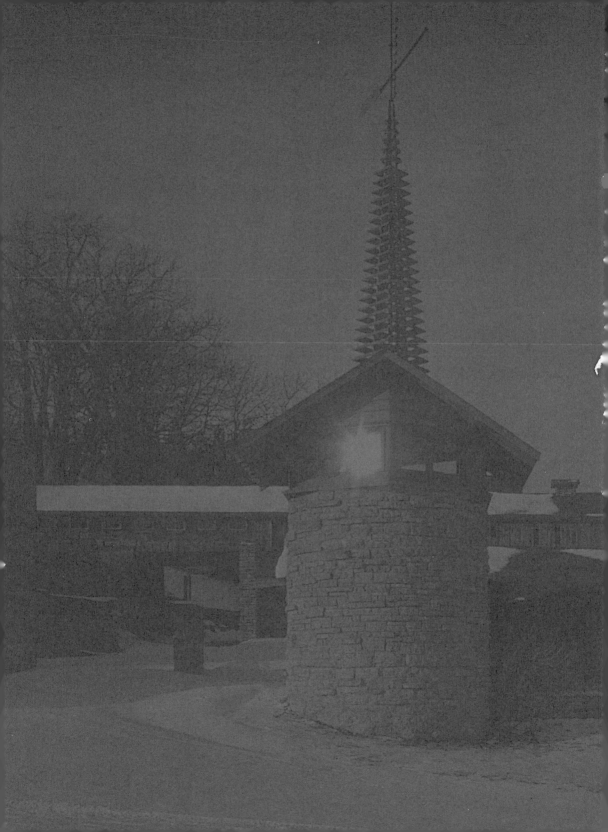